RENAISSANCE PAINTING
FROM BRUEGHEL TO EL GRECO

RENAISSANCE PAINTING
FROM BRUEGHEL TO EL GRECO

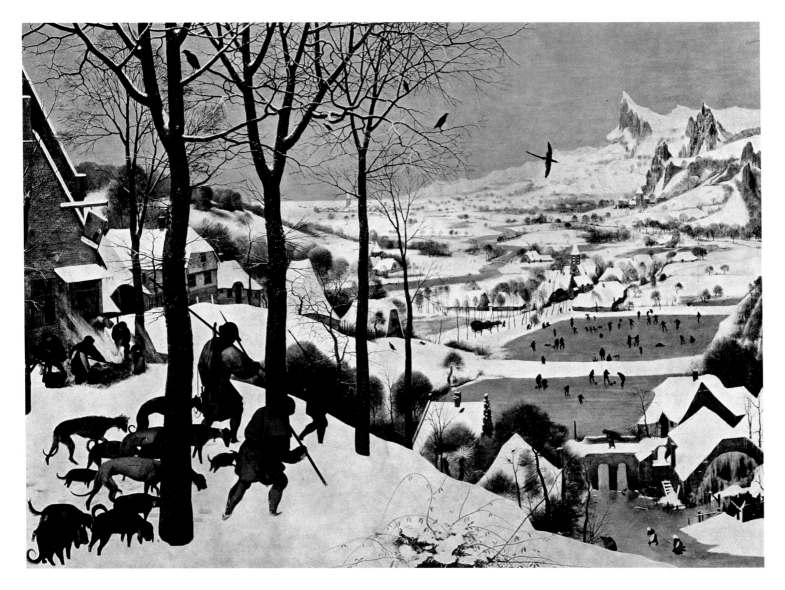

TEXT BY LIONELLO VENTURI

RIZZOLI
NEW YORK

Originally published in the
GREAT CENTURIES OF PAINTING
series created by Albert Skira

*

Color plate on the cover :
El Greco (1541-1614). St Maurice, detail from The Martyrdom
of St Maurice, ca. 1580-1582. Monastery of the
Escorial, near Madrid

*

Color plate on the title page :
Pieter Brueghel (ca. 1525/30-1569). Hunters in the Snow, 1565
(46 ×63¾″) Kunsthistorisches Museum, Vienna

© 1979 by Editions d'Art Albert Skira S.A., Geneva
First edition © 1956 by Editions d'Art Albert Skira, Geneva

This edition published in the United States of America in 1979 by
Rizzoli International Publications, Inc.
712 Fifth Avenue/New York 10019

Translated by Stuart Gilbert

Library of Congress Catalog Card Number: 56-9860
ISBN: 0-8478-0207-8

PRINTED IN SWITZERLAND

CONTENTS

1

PAINTING IN THE NETHERLANDS

2

PAINTING IN VENICE

3

MANNERISM

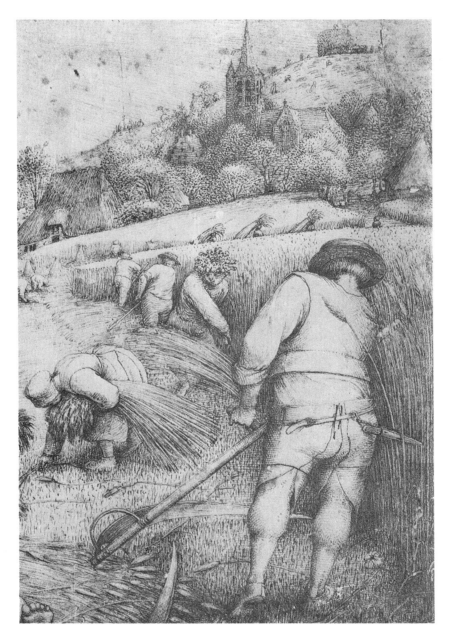

PAINTING IN THE NETHERLANDS

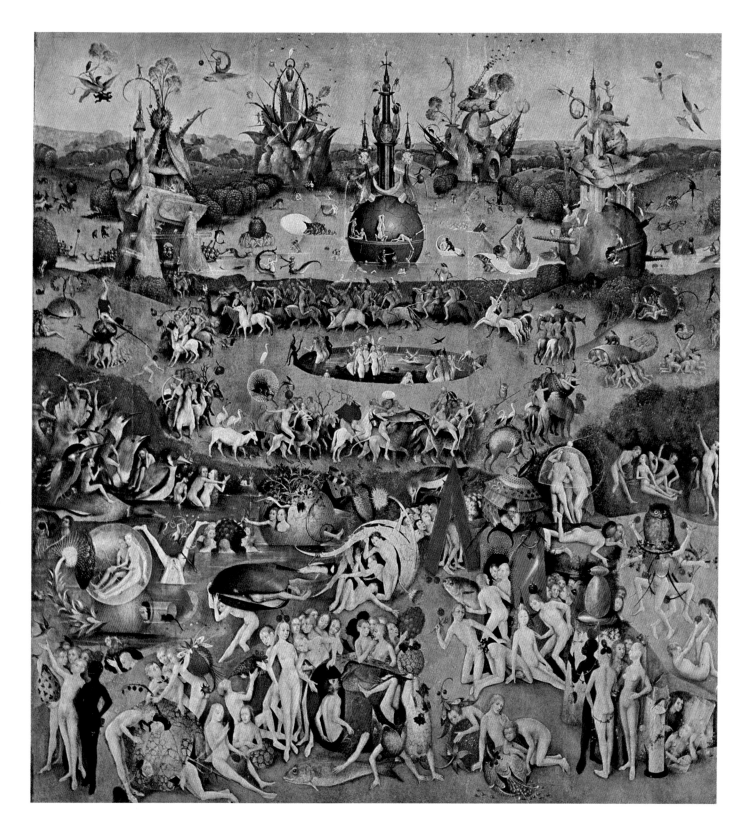

HIERONYMUS BOSCH (CA. 1450-1516). THE GARDEN OF EARTHLY DELIGHTS, CA. 1485. (86½ × 76½″)
CENTRAL PANEL OF A TRIPTYCH. PRADO, MADRID.

I

FROM BOSCH TO BRUEGHEL

O N the threshold of the 16th century Flanders, unlike Germany, had behind it a great art tradition: that of Van Eyck and his successors. And though there had been frequent exchanges of ideas between the Flemings and the Florentines throughout the 15th century, the two art streams had never converged; there was still a basic incompatibility between the Northern artists' outlook on the world and that of the Italians. Florentine painting stood for the humanist ideal and the aesthetic of the Renaissance, whereas Flemish artists remained faithful to the religious tradition of the past, while carrying to its extreme limit the realism that had characterized late medieval art. But at the close of the 15th century the traditional art of the Low Countries underwent a radical change, particularly conspicuous in the work of Bosch.

The mood of Van Eyck's art was one of total serenity, of a profoundly pious mind at peace with itself and with the world at large. One feels that no shadow of doubt ever crossed his mind; assured of knowing all that needed to be known about man and nature, he depicted them with loving care, down to the least detail, and with a craftsmanly skill that has never been excelled. Looking at his paintings, we have a momentary conviction that the world is indeed just as he shows it, an earthly paradise beatified by the divine light of God and by that of its visible counterpart, the sun.

Around 1480 the most highly esteemed painter at Bruges was Hans Memling, a man as little troubled as Van Eyck by any doubts as to the perfection of the natural world. He had a delicate sense of human beauty but, as compared with the art of his immediate predecessors, both the aesthetic quality of his work and its spiritual message seem superficial. In that same year, 1480, Bosch was producing work utterly unlike Memling's; most pessimist of painters, he saw the devil rather than the God in man and was more concerned with giving unfettered expression to his nightmare visions than with celebrating the beauty of the Madonna.

The contrast between Memling and Bosch reflects the conditions of life in the Low Countries at the end of the 15th century. Commerce and industry were thriving and the cities rapidly acquiring great wealth. The court of the Dukes of Burgundy at Brussels was one of the most sumptuous in Europe and the Church had successfully adjusted mystical effusion to a well-ordered pattern of dogmas, symbols and sacred images controlled by a rigid iconography. But there was also much poverty and the country was so full of tramps and beggars that it was found necessary to organize a

system of relief. Though frowned on by the Church, the mystical tradition still held its own; it was a tradition stemming from Jan van Ruysbroeck (1293-1381), the "Ecstatic Teacher," and from Geert Grote (1340-1384) who censured the misdeeds of the clergy and called for a moral and religious revival among the laity.

The religious conflicts of the Late Middle Ages made themselves felt with extreme virulence in Flanders. As Huizinga has pointed out, "the 15th century was a period of terrible depression and a life-sickness that boded ill for the future... Gloomy forebodings haunted the mind of 15th-century man: a constant fear of oppression and deeds of violence, obsessive thoughts of hell and the Last Judgment, of the perils of fire, famine and plague, of the nefarious doings of witches and evil spirits." But there was no hint of these apprehensions in the art of Van Eyck's disciples; whereas they loom large in that of Bosch.

HIERONYMUS BOSCH

Hieronymus Bosch (ca. 1450-1516) was born at Bois-le-Duc, called 's-Hertogenbosch in Dutch. Former capital of North Brabant, 's-Hertogenbosch was far removed from the great centers of Flemish art and strongly traditionalist in spirit. Bosch's father and grandfather were painters, and the family hailed from Aachen in Germany; hence the family name "Van Aken." But Hieronymus preferred to be known as "Bosch," last syllable of the name of his birthplace. There are frequent references to him in the records of the Brotherhood of Our Lady at Bois-le-Duc between 1480 and 1512; from them we learn that he was a member of the orchestra and regularly took part in the mystery plays—which goes to show that he spent all or most of his life in his hometown.

Temperamentally independent as a man and as an artist, he stood outside the art currents then developing in his native land and kept nearer to the tradition of the illuminators than to that of Flemish painting. But so adventurous was his genius that, with his eyes fixed on the past, he glimpsed what was to be the art of the future. Except in a few works dated after 1500, he shows no sign of any knowledge of humanism or of the Renaissance. He was a wholly medieval painter who, unwittingly bypassing the Renaissance, anticipated modern art.

The *Hay Wagon*, the *Garden of Earthly Delights* in the Prado and the Lisbon *Temptation of St Anthony* are works in which both subject and motifs were entirely original creations of the artist's imagination. The theme of the *Hay Wagon* comes from an old Flemish proverb: "The world is a heap of hay and everyone takes from it whatever he can grab." On the left wing are *The Fall of the Rebel Angels*, *The Creation of Eve*, *The Temptation* and *Adam and Eve expelled from Paradise*. This last scene acts as a prelude to the vision of moral degradation symbolized by the people crowding round the wagon, while on the right wing is a vision of Hell, lit by the glare of leaping flames —the destination of the persons represented on the central panel, the *Hay Wagon*. The latter contains a great number of small figures, amongst them the Pope, the Emperor and princes following the cart. A crowd is scrambling on to it, trying to snatch a wisp of the delectable fodder; some are falling under the wheels, others are eating and drinking or making music. On the side panels, when closed, is the *Prodigal Son*.

The Lisbon *Temptation of St Anthony* represents a fantastic Witches' Sabbath, in which fish, pigs and all kinds of animals assume more or less human forms. It is one of those weird "caprices" to which Bosch owes his fame and in which he conjures up from his prolific imagination unheard-of tortures and indulges in preposterous distortions.

In the *Garden of Earthly Delights* we are shown a seething mass of tiny figures acting out their vices in accordance with an elaborate symbolism like that set forth in the medieval dream-books. "The cherries, raspberries, strawberries and grapes they are being given and eating with such gusto are symbols of sexual pleasure. The apple-boat sheltering the lovers recalls a woman's breast, the birds symbolize lust and shame, and the fishes the thrills of sensual delight or secret fears, while the mold is a female emblem. Here Bosch has represented in telling form the repressed desires haunting the subconscious" (Charles de Tolnay). The wings, left and right, when open represent the Earthly Paradise and Hell respectively; when closed, a large, transparent sphere, the earth enveloped in water before the creation of man.

Thus the three pictures are allegories with a moral purpose, depicting the punishments in hell awaiting those who yield to the triple lure of the world, the flesh and the devil. They embody three commandments in pictorial form: Be chaste, Love poverty, Shun temptation. But though the painter was careful to include all the symbols of his message and took infinite pains over rendering each exactly, we may question if, being what they are, these extraordinary pictures really served a moral purpose.

At first sight one wonders why Bosch peopled these scenes with such tiny figures. But we have only to imagine the effect they would have produced had they been of normal size—in which case their lewd or uncouth postures would certainly have shocked the beholder. As it is, their smallness makes each scene look like a Lilliputian carnival or a puppet play. True, there are allusions to unnatural vices in the *Garden of Earthly Delights*, but these take the form of symbols; the manikins themselves are as chaste as anyone could wish. What is more, their facial expressions are childishly naïve. Far from "representing," Bosch merely "presents" these figures along with their symbols.

These observations are all the more pertinent when we remember that, anyhow in the *Hay Wagon* and the *Temptation of St Anthony*, the scenes purported to be dramatic. But Bosch was incapable of dramatic effects, even where these were called for and one cannot help feeling that those who read into his work an image of the degradation and anguish of the age he lived in tend to overvalue the moralist as against the artist.

The mainspring of his art is a prodigiously fertile and uninhibited imagination which, striking down to the subconscious, probes the depths of mind and heart, though without taking any of its finds too seriously, and on its return from these subliminal adventures tells the tale of them with cheerful gusto. For the world Bosch evokes is an imaginary one whose denizens are of the stuff that dreams are made of and no more tragical than Prospero's familiars. His lightness of touch and airy freedom enable him to create exquisitely lovely figures—pure despite the symbols—clad in the most delicate of colors. In short we cannot agree with those modern art critics who see in Bosch an expressionist or surrealist born before his time.

To appreciate Bosch's originality as a colorist, we must recall the use of color in the works of Van Eyck's school, for example in the *Portinari Altarpiece* (Uffizi), masterpiece of Hugo van der Goes. In it every color is given a jewel-like luster and we can see the artist's sensitivity of vision in his handling of the lights and shades flickering across each detail. Nevertheless the colors are everywhere conditioned by the images, and are not in any sense autonomous.

HIERONYMUS BOSCH (CA. 1450-1516). THE GARDEN OF EARTHLY DELIGHTS (DETAIL), CA. 1485. CENTRAL PANEL OF A TRIPTYCH. PRADO, MADRID.

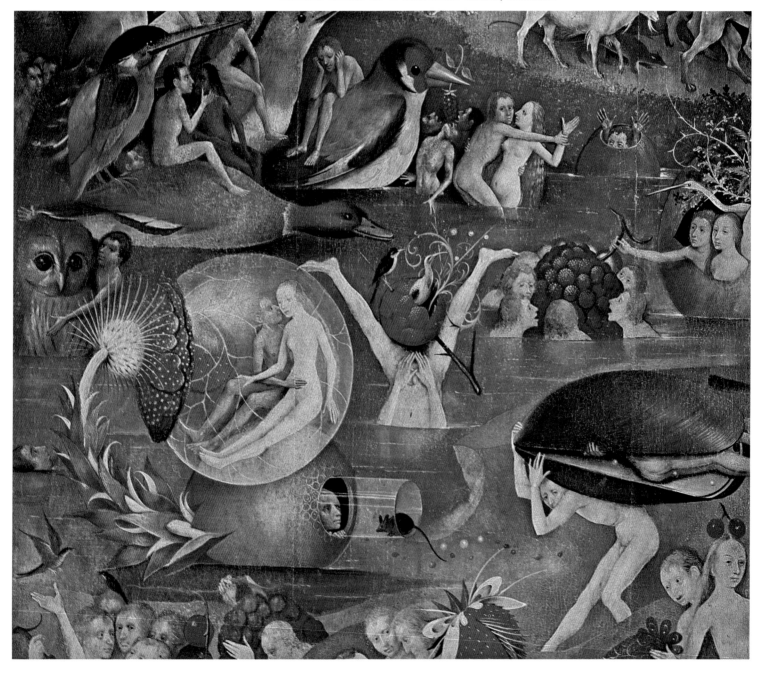

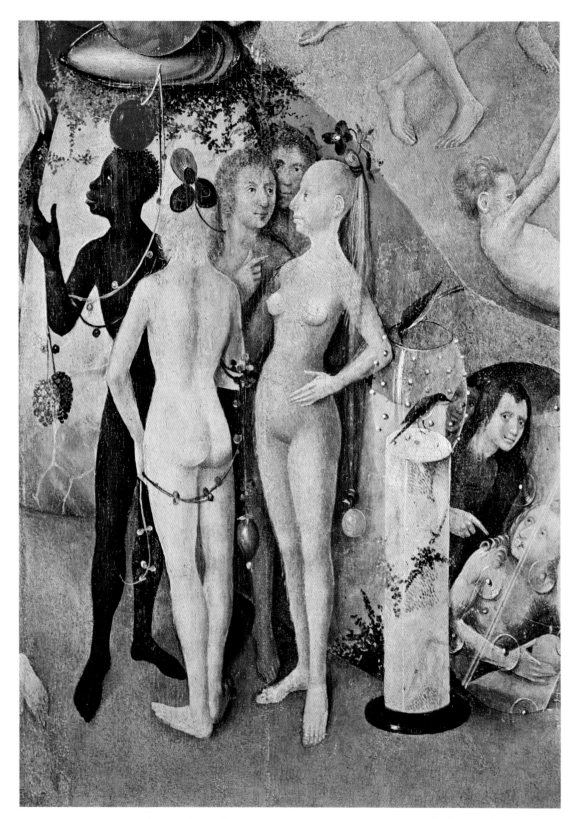

HIERONYMUS BOSCH (CA. 1450-1516). THE GARDEN OF EARTHLY DELIGHTS (DETAIL), CA. 1485.
CENTRAL PANEL OF A TRIPTYCH. PRADO, MADRID.

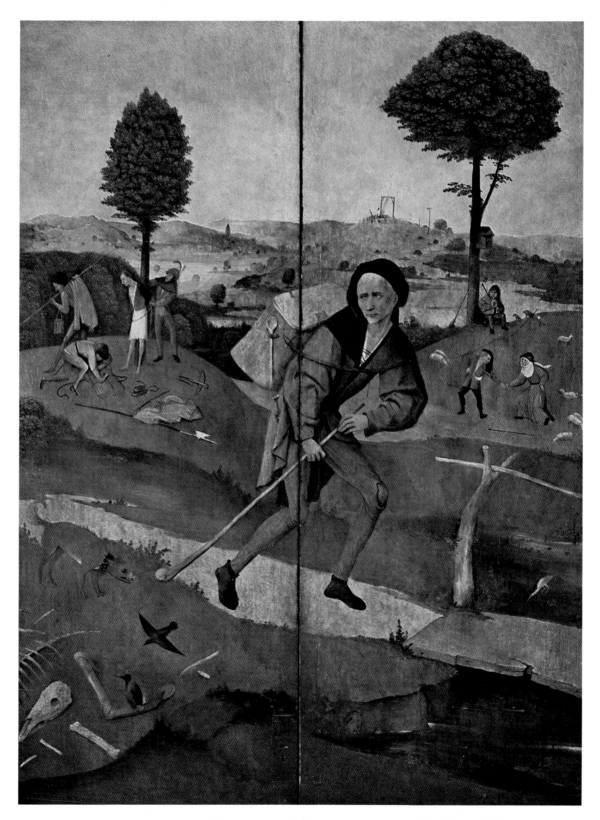

HIERONYMUS BOSCH (CA. 1450-1516). THE PRODIGAL SON. (53⅛ × 39¼″)
CLOSED WINGS OF THE "HAY WAGON" TRIPTYCH. PRADO, MADRID.

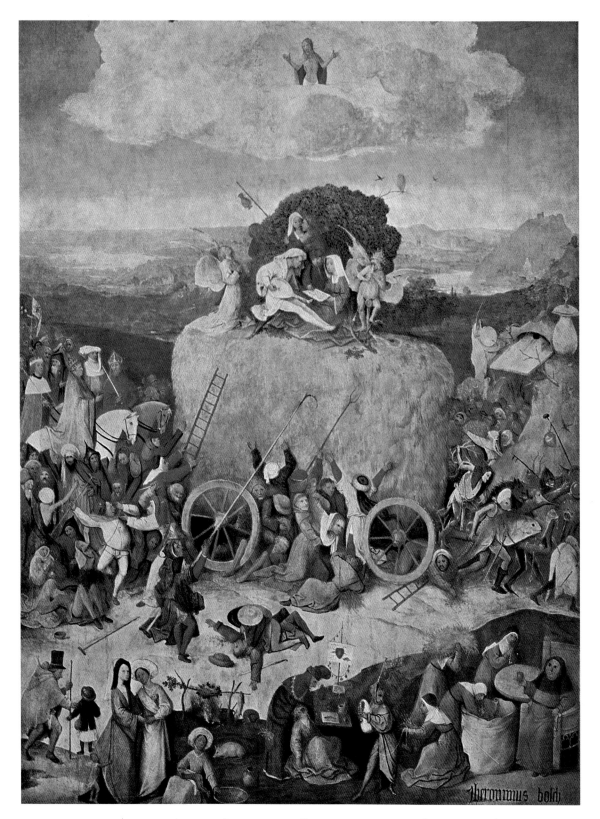

HIERONYMUS BOSCH (CA. 1450-1516). THE HAY WAGON. (53⅛ × 39¼")
CENTRAL PANEL OF A TRIPTYCH. PRADO, MADRID.

Bosch was the first Nordic painter to achieve the color-light synthesis and keep in mind the tonal unity of the composition as a whole. In the fire in the background of the *St Anthony*, in the town on the right wing of the picture and, generally speaking in all his landscapes, color is used in a manner that was at the time entirely new.

In connection with the three major works discussed above, mention may here be made of some smaller ones which throw light on them from various angles. There is, for example, a series of pictures which, despite their religious subjects, are essentially genre scenes; also some illustrations of proverbs and texts. Though the theme of *The Miser's Death* (Private Collection, New York) derives from the *Ars Moriendi*, its tenor is far from being religious. In it Bosch expounds the vanity of human life with withering irony. The miser is reaching for a bag of gold while an angel bids him turn towards the crucifix and, in the foreground, a thief, holding a rosary in his left hand, stretches out his right towards the money a small devil is offering to him. Standing on the threshold, Death is letting fly an arrow at his victim, the arrow painted with extreme delicacy and precision, as though the artist, with cynical intent, wished to rivet our attention on it. Here, again, there is nothing dramatic in the scene. The light hues of the dying man, telling out in the middle distance against the red and green of the setting as a whole, draw our gaze towards him but, like Death and the thief, he does not seem really concerned with what is happening. What Bosch pictures here is not a conflict of angels and devils over a Christian deathbed; with elegance and feeling, he illustrates the ruthlessness of destiny and the predicament of a soul wavering between vice and virtue.

When painting the *Seven Deadly Sins* (Prado) to decorate a tray, Bosch felt free to introduce motifs culled from popular farces. In *Gluttony* the table manners of the two men eating and drinking are so gross as to be frankly comic and no less ludicrous in *Anger* is the contrast between the would-be ferocity of the gesticulations and their complete innocuousness. Presumably Bosch (anticipating Bergson) saw in ridicule an instrument for curing humanity of its vices, and felt no need to dramatize them.

The *Ship of Fools* in the Louvre (illustrating Sebastian Brant's satirical poem *Das Narrenschiff*, published at Basel in 1494) is full of whimsical inventions, though the formal structure, built up by images in profile painted flat on a background of leafage, is rigorously synthetic. We find similar forms in the mystical scenes of the Berlin *St John in Patmos*, whose themes may have derived from engravings of the "Master E. S." and Schongauer; if so, Bosch thoroughly transformed them and in so doing produced a singularly fine seascape worthy of the greatest Dutch landscape painters of the 17th century. But what strikes one most in this work is its visionary power, sublimating every detail on to a mystical plane; it contains no action, no expression of any definable sentiment, but by his very fidelity to the sacred text the artist brings before us the world of strange enchantments glimpsed by the seer of the Apocalypse.

In the *Altarpiece of the Hermits* (Ducal Palace, Venice), depicting St Anthony, St Jerome and St Giles, though the forms of the devils trying to distract the saints from their prayers are grotesque to a degree, the figures of St Jerome and particularly St Giles

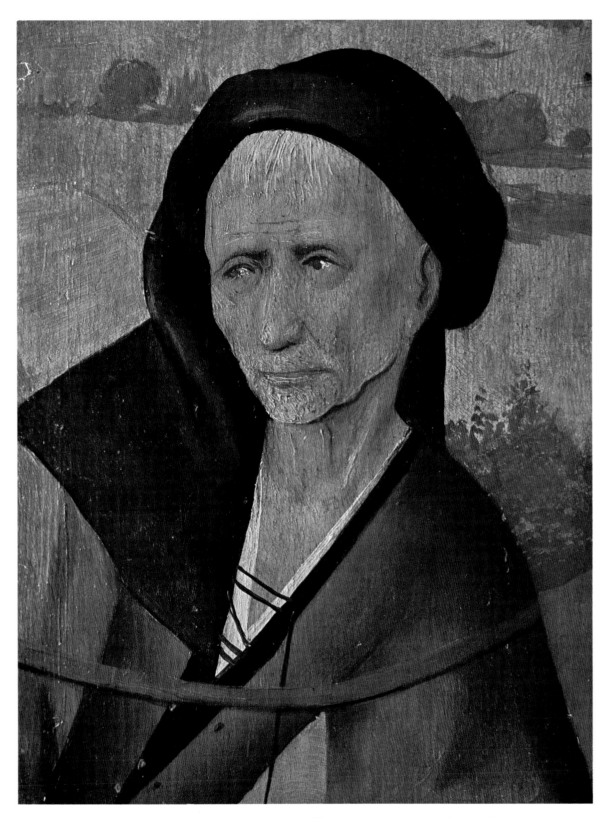

HIERONYMUS BOSCH (CA. 1450-1516). THE PRODIGAL SON (DETAIL).
CLOSED WINGS OF THE "HAY WAGON" TRIPTYCH. PRADO, MADRID.

are invested with a wonderful spiritual purity, attesting the artist's deep religious sensibility. Less successful to our thinking are the *Ecce Homo* (Philadelphia) and the various versions of the *Bearing of the Cross* in which the artist's lack of a dramatic sense weakens the general effect. Thus he fails to bring out the vulgarity and bestiality of Christ's tormentors, and he similarly fails to spiritualize the face of Christ. Though forms and colors are handled with consummate elegance, the subject was manifestly unsuited to his peculiar genius.

As with many painters, it is the drawings that reveal his style at its clearest, most spontaneous. The figure studies for the *Conjuror* (Louvre), with their light touches and breaks in the line, are wonderfully vivacious. True, the Gothic elements in his art are more prominent in his drawings than in his paintings, yet in *Forest that listens and Field that sees* (Kupferstich Kabinett, Berlin) and *Owl's Nest on a Branch* (Rotterdam) medieval symbolism and Gothic whimsy do not detract from the pictorial values of the composition as a whole; such indeed is the freedom and broadness of the execution that they rank beside the finest Venetian drawings of the 16th century.

In the artist's last works (i.e. those thought to be subsequent to 1500) a great change has come over his style. To begin with, the human figure is treated on a larger scale and for this reason greater stress is laid on plastic values. Also, there are signs of a new, more responsible moral attitude towards the persons represented. This becomes evident when we compare the Prado *Adoration of the Magi*, a work of Bosch's last phase, with the Philadelphia version of the same theme, made in his youth. The latter is a medieval story-teller's picture, naïve, fanciful and daintily executed without any great concern for composition; in the Prado version, on the other hand, the figures are grandiose, wholly subordinated to their religious function, and instinct with dignity. The same is true of the personages in the side panels: donors and their sponsors watching the sacred scene. Here all the qualities of the artist's early style are present but, with them, a new feeling for architecturally ordered composition. The background consists of an exquisitely rendered landscape, endowed with a poetic glamour singularly "modern" in tone. Also in the Prado is a *Temptation of St Anthony* belonging to the last period. Demons and their retinue of hybrid monsters still are present but the figure of the saint dominates the scene, its volumes stressed by strong foreshortenings; while the face expresses a serene, unwavering faith and an invincible determination to withstand the tempter's wiles.

Greatest perhaps of the works of Bosch's last period is the *Prodigal Son* (Boymans Museum, Rotterdam). When we compare this with his rendering of the same theme on the side panels of the *Hay Wagon* (Prado) we see that in the latter it is treated anecdotally, like an incident of village life. But in the Rotterdam version the prodigal son is shown as the protagonist, a commanding figure skillfully adapted to the octagonal shape of the panel. Vigorous modeling and bold design, combined with more closely knit composition, enable the artist to bring out more clearly the affective values of the scene. The returning prodigal bears the marks of his privations, has realized the folly of his ways and timidly pleads to be taken back into the home he has forsaken.

There is a haunting pathos in his gaze as he craves forgiveness, and his somber mood is mirrored in the uniform greyness of the countryside and sky, against which the softest, tenderest colors of Bosch's palette shine out gently, like a promise of compassion.

For towards the close of his life Bosch abandoned that mood of savage irony which gives his early work its piquancy, and developed a new sense of moral responsibility, reflected in a tightening-up of his composition and a greater concern with modeling. What, we may wonder, were the reasons for these changes? Was it that on the threshold of old age he gave more thought to the serious side of life? Or was it that he then had come, if by indirect channels, under the influence of Italian art, as is suggested by the *sfumato* in the Ghent *Bearing of the Cross*?

All the same his creative powers are seen at their best when he is in his satirical vein, so well seconded by his broken line and softly luminous colors. It was this that led him to react against the dogmatism of the medieval Church and to champion the cause of the common people, helpless victims of ecclesiastical oppression and social prejudice. To start with, Bosch applied himself to scourging the follies of his time but he gradually moved towards a purer mode of expression, imbuing even the vulgarest images with the sensitivity that had come to him in his middle years. Little by little he achieved a serener vision, putting fantasy to the service of that which is inexplicable in terms of reason. And in the end he gives a glimpse of his true feelings, a vast pity for mankind and a truly Christian charity, in the gaze of the *Prodigal Son* whose folly has brought him to perdition.

QUENTIN MASSYS

Bosch was too isolated a figure to be the founder of a school, though many artists (even in Italy) borrowed or adapted some of his motifs without, however, troubling to integrate them in a coherent whole. The only artist who followed in his steps and infused new life into his discoveries was Pieter Brueghel.

Not that there was any dearth of able artists in the Low Countries at the time, one such being Gerard David, who still kept to the traditions of the 15th century. The first to try to graft the art of Leonardo on to the Eyckian tradition (as represented by Dirk Bouts) was Quentin Massys, born in 1466 at Louvain. The earliest mention of him is an entry, dated 1493, in the records of the Guild of St Luke at Antwerp naming him a member. Though resident in that city till his death in 1530, he never lost touch with his hometown and in 1507 was commissioned to paint a triptych for the Confraternity of St Anne at Louvain; this work was completed two years later. In 1508 the Antwerp Carpenters' Guild ordered from him a *Pietà* (finished in 1511) for their chapel in the local cathedral. By this time Massys evidently enjoyed an international reputation, since in 1509 he got an order from Lisbon. He was on friendly terms with some of the most enlightened men of the age, amongst others Thomas More and Erasmus. During his visit to the Netherlands, Dürer called on him, but the two artists do not seem to have taken to each other.

The Brussels *St Anne* triptych (1507-1509) best illustrates the rather special nature of his art. In the central panel are the Virgin, the Child and St Anne, and in the

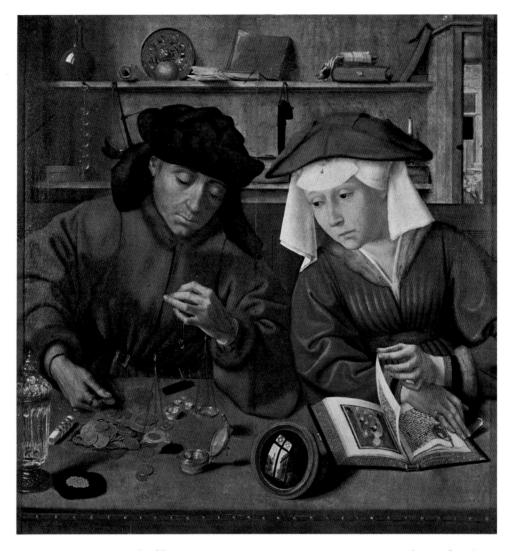

QUENTIN MASSYS (1466-1530). THE BANKER AND HIS WIFE, 1514. (29 × 26¾″)
LOUVRE, PARIS.

foreground, seated beside their children, the Marys of Scripture with four men a little behind them, and some Italianate architecture in the background. This might well be a domestic picture of the household of some opulent, complacent burgher; the men are properly sedate while the women are all grace and smiles. These people seem to belong to the class of the new-rich then coming to the fore in Antwerp. Similarly the scene of the *Death of St Anne* on a side panel is represented with a dainty elegance better suited to some ceremonious occasion than to the tragic event it purports to depict. The composition of the Antwerp *Pietà* (1508-1511) is inspired by Rogier van der Weyden's masterpiece of the same name, but it lacks the spirituality of its proto-type, failing to convey any real sense of grief. The people painted by this artist belong to an élite preening itself on its refinement, and though their nerves are always on the stretch they seem incapable of genuine passion.

But Massys has a keen feeling for beauty, if a somewhat formal beauty, fined down to its purest elements. This can be seen in the group formed by Mary, wife of Zebedaeus, with her two sons, James the Greater and John the Evangelist (central panel of the *St Anne* triptych) and in the *Three Marys at the Tomb* (formerly in Berlin), where the smiling grace of the figures is hardly ruffled at all by any outward sign of grief. In his pictures of the Virgin, Massys kept to the Eyckian tradition, while stressing volumes in the Renaissance manner (e.g. the superb *Virgin* in Brussels and that in the Dyson-Perrins Collection, London). On the other hand, when he lets himself be influenced too strongly by Leonardo, he makes blunders, as proved by the Poznan *Virgin*, obviously copied from Leonardo's *St Anne*. Sometimes, apparently conscious of his shortcomings, he sets out to emphasize expressive and emotive values, as in the Berlin *Virgin Enthroned*, where he represents the Mother kissing her Son—with ludicrous results.

His feeling for Renaissance art led him to invest his figures with dignity, but dignity of a social rather than a moral order. Thus he was poles apart from Bosch and when he tried to emulate him lost his bearings. The *Ecce Homo* at Madrid looks like a self-caricature, and the *Temptation of St Anthony* (whose landscape setting was done by Patinir) like a garden party that has taken an erotic turn. The women's figures, and even the saint's, are gracious, winsome—and suggestive.

By far the most popular of Massys' pictures is the *Banker and his Wife* (Louvre), painted in 1514, which shows the couple seated side by side at a table on which are gold coins, a mirror and other tokens of their wealth. Behind them are two shelves strewn with books and miscellaneous objects, rendered with much accuracy and skillfully disposed. The man, who is weighing coins, seems to have fallen into a brown study while his wife who has been perusing an illuminated book turns towards him, a pensive look on her face. They are represented as thoughtful, amiable people, curiously indifferent to worldly concerns, despite the husband's occupation. (In this connection we must remember that to the medieval mind anyone whose business involved dealing in money was usually styled a "usurer.") Seemingly what Massys was aiming at here was to achieve a purely formal beauty by excluding all expressive elements; if so, he failed in his attempt, and this indeed is what makes this little genre piece so delightful.

Given Massys' temperament as set forth above, it was only to be expected that he would excel as a portrait painter. And in fact he had a gift for seizing on the decisive moment when a character betrays itself in a casual gesture or fugitive expression. Typical examples of this can be seen in the diptych, dated 1517, containing portraits of Erasmus (now in the Galleria Nazionale, Rome) and Petrus Aegidius (Longford Castle, Salisbury), in which the figures, done from the life at a revealing moment, bring the very men before our eyes.

There are, however, other portraits of a different nature, those which are built to an architectonic plan, deriving perhaps from Giovanni Bellini. Typical of these is the *Ecclesiastic* (Liechtenstein Collection, Vaduz), whose pyramidal structure standing up against a landscape background gives an impression of massive power, like that of a monument built to last forever.

JOACHIM PATINIR Born at Bouvignes (near Namur, in present-day Belgium) some time between 1475 and 1480, Joachim Patinir is first mentioned in 1515 as a painter at Antwerp, where he died in 1524. He may have studied with Gerard David at Bruges and certainly collaborated with Quentin Massys at Antwerp. Inspired by Bosch, he specialized in panoramic landscapes which, such is their topographical precision, might almost be described as pictorial maps. These earned him an international reputation. Dürer spoke highly of his landscapes and the Spanish connoisseur Felipe de Guevara, writing about 1540, ranked him with Van Eyck and Rogier van der Weyden among the leading Flemish masters.

While it is true that none of the works unquestionably his are ever without figures, these figures, notably in his religious scenes, are extremely small, dwarfed by the vast expanse of countryside that fills the picture. Patinir in fact, as all contemporary observers noted, was essentially a landscape painter and it was as such that he made his name. As we have seen, the figures in his *Temptation of St Anthony* (Prado) were painted in by Quentin Massys. Here we have an example of that collaboration between artists which,

JOACHIM PATINIR (1475/80-1524). CHARON'S BOAT. (25 ¼ × 40 ½ ")
PRADO, MADRID.

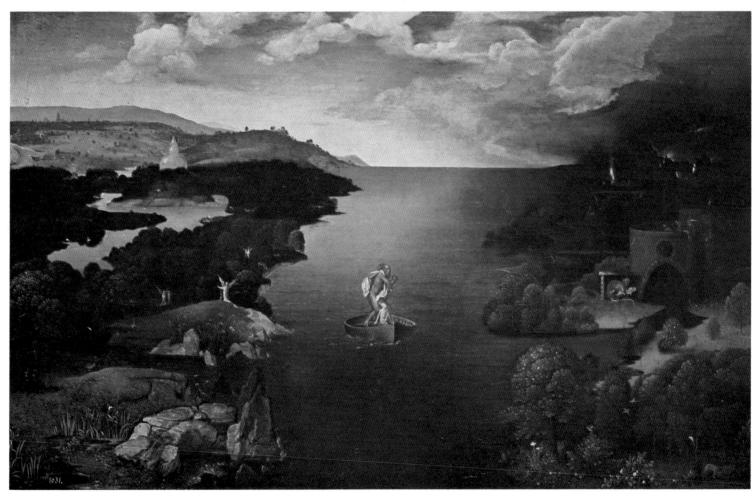

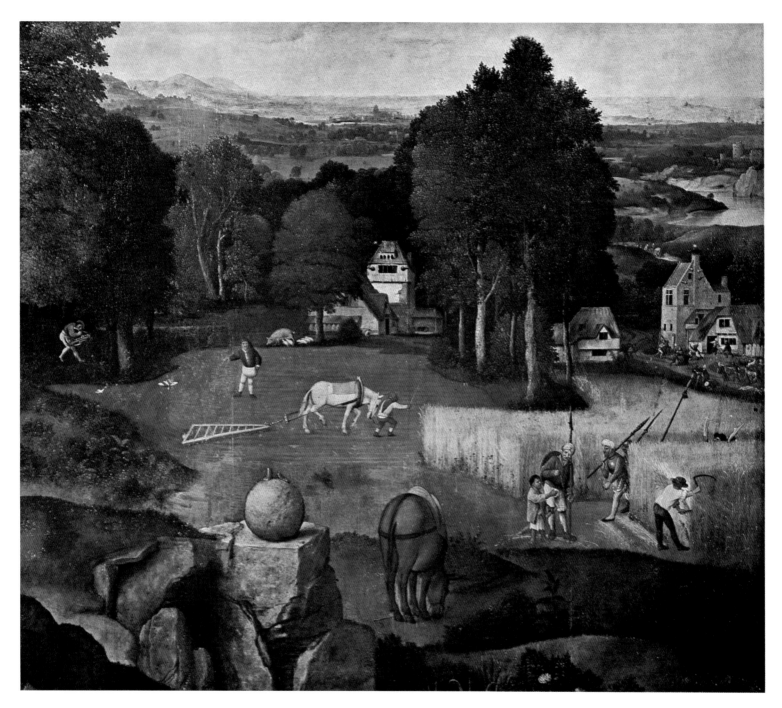

JOACHIM PATINIR (1475/80-1524). THE REST ON THE FLIGHT INTO EGYPT (DETAIL). PRADO, MADRID.

while very rare in the early 16th century, became a common practice in the next, when each painter tended to confine himself to a specific genre: landscape, still life and so forth. Patinir's specialization in landscape led him to devote much interest to the technical problems peculiar to this form of art. For example he raised his horizon so as to embrace as wide a stretch of country as possible, using three basic tones: brown

for the foreground, green for the middle distance, blue for the mountains spanning a remote horizon. Friedländer attributes the popularity of Patinir's landscapes—proved by their many imitations—to the new conditions under which works of art were then being bought and sold. Up to the end of the 15th century artists painted what local authorities and influential private patrons commissioned them to paint, and little else. But in the prosperous city of Antwerp in the early 16th century—as also in Venice— painters were beginning to cater for the hypothetical buyer, for the art lover who visited artists' studios, inspected the finished works and bought the ones that caught his fancy. Conditions, of course, were not everywhere favorable to artists; in Basel, for example, Holbein was hard put to it to find customers. Then, too, with Protestantism sweeping over the North (with iconoclasm in its wake), the private buyer may have shied away from religious scenes; to him a landscape, pleasing to the eye and non-committal, must have seemed the safest picture to acquire.

In such a work as Patinir's *Flight into Egypt* (Antwerp) we notice that the tiny group of figures representing the Holy Family actually counts for very little in the picture. Most prominent are a strange rock formation, a clump of trees and three or four houses; beyond these are woodlands and fields forming a wide circle around a land-locked bay; in the background are mountains and a wide stretch of sky dappled with drifting clouds. This type of landscape differs greatly from that of Altdorfer; its far-flung vistas lure the eye to explore the distant scene and linger on a gay profusion of colors before coming to rest on a far horizon. But a vision of this kind was not self-sufficing, it had to "tell a story." The landscape became a work of art in its own right only when the panoramic view dissolved into a general effect of light and shade, as was the case with the great Dutch landscapes of the 17th century. Still, as a representation of nature the *Flight into Egypt* is a good specimen of the genre to which it belongs, fascinating in its variety of motifs and for the finesse of the execution. This type of landscape became so popular that it persisted until the end of the century.

Similar to it, but more broadly treated, is the *St Jerome* in the Duensing Collection (at Boizenburg, near Hamburg); here the rocks are even more contorted and fantastic. No less strange are the arbitrary shapes of the mountains, tooth-like projections interspersed with castles and caves, in the two versions of the *Assumption of St Mary of Egypt* (Duensing Collection and Crespi Collection, Milan); these scenes also include some animistic motifs borrowed from Bosch. In the Prado *St Jerome* the contrasts of light and shade in the landscape are given an independent pictorial value above and beyond mere panoramic effect. The bright sky overhung with lowering clouds is reflected in the clear waters of the river bordered by dark woodlands. Nowhere in Patinir's work are such light effects better realized than in the Prado *Charon's Boat*, where running up perpendicularly to the horizon the sluggish river mirrors the brightness of the sky with an intensity enhanced by the black trees on the bank. A pallid figure paddling a white boat, Charon is ferrying a lost soul to the Underworld whose leaping flames we glimpse on the far right. Despite the nature of the theme, the mood of the landscape is one of fine serenity, an idyll in Patinir's best vein.

Jan van Scorel was born at Schoorl, near Alkmaar, in 1495 and died in 1562.
A product of the 15th-century realist tradition in the Netherlands but shaped by a
diversity of later influences, his art evolved first in the direction of Gossaert, then in
that of Dürer. After a long journey through Germany and Austria to Venice, and a
voyage to Palestine, he settled in 1521 in Rome, where he studied ancient art and the
works of Raphael and Michelangelo. In 1522 Adrian VI, a Dutchman, was elected pope
and he appointed Scorel, then aged twenty-seven, to succeed Raphael (who had died
in 1520) as keeper of the art collections at the Vatican. But the pope died in 1523,
and next year Scorel returned to Holland, working for a time in Haarlem, then settling
in Utrecht. This was a considerable fund of experience for an artist not yet thirty years
old and it fully accounts for his abrupt change of style. That he was able to veer from
northern realism to Italian mannerism without losing his balance says much for the
versatility of his talent.

The *Portrait of Agatha van Schoonhoven* (Galleria Doria, Rome), being dated 1529,
was painted after his return to Holland. It is one of his masterpieces, firmly rooted in
the Dutch portrait tradition, yet embellished by that Italian grace and suavity whose
secrets he had learnt in Rome. These combine to make it a typical work of the northern
Renaissance. In other pictures, however, Scorel drew heavily on mannerism; in *Bathsheba*
(Amsterdam), for example. Here there is no action and the nudes are considerably
elongated—one in fact is copied from a sculpture by Michelangelo—while the landscape,
on the other hand, still keeps to the Flemish tradition.

By and large, Scorel exerted a marked influence on mannerism in the Netherlands,
an influence that will be discussed in our last chapter, dealing with the spread of
mannerism throughout Europe.

The importance of Lucas van Leyden lies in the fact that his style is markedly
different from the traditional Flemish style and has many features in common with
that of the great Dutch artists of a later generation. In his lifetime he was famous as
an engraver rather than as a painter; the same is true of Dürer, whose influence on him,
in all respects, was far stronger than that of the Flemings. Lucas might be described
as one of the many painter-storytellers of the Middle Ages; he drew and painted,
however, with an uncompromising sincerity and bluntness of statement worthy of
a protestant reformer, though he never actually renounced the catholic faith. What
interested him most was the correct delineation of the human figure, his interest
in it being essentially technical, not aesthetic. Throughout the 16th century his name
was a household word amongst artists all over Europe, even in Italy, stress being laid
on his complete originality.

Born at Leyden in 1494, he was trained first by his father Hugo Jacobsz, then
by Cornelis Engelbrechtsz. The boy proved to be something of a child prodigy and
rapidly made a name for himself. In 1517 he married into one of Leyden's leading
patrician families. In 1521 we find him at Antwerp where he met Dürer; the two became
fast friends and each presented the other with a set of his prints. In 1527 Lucas made

a tour of the Netherlands, junketing and reveling all the way and, as contemporary observers noted, "living like a lord"; he returned to Leyden a sick man. Thereafter his health steadily declined and he died in 1533, not yet forty. A tissue of legends quickly grew up around his name, which, though doing much to spread his renown, tended to obscure the true facts of his life.

In Brunswick Museum is a *Self-Portrait* painted by Lucas at the age of fifteen. Brutally forthright, dashed off with a turbulent vitality reminding us of Frans Hals, this is not only the work of a strong personality, but contains in embryo much that was to characterize Dutch painting a century later. Both in his prints and paintings, Lucas proved himself an unflinching realist, though mannerist elements usually make their presence felt beneath his realism.

LUCAS VAN LEYDEN (1494-1533). CARD-PLAYERS, CA. 1514. (14 × 18 ⅝″)
COLLECTION OF THE EARL OF PEMBROKE, WILTON HOUSE.

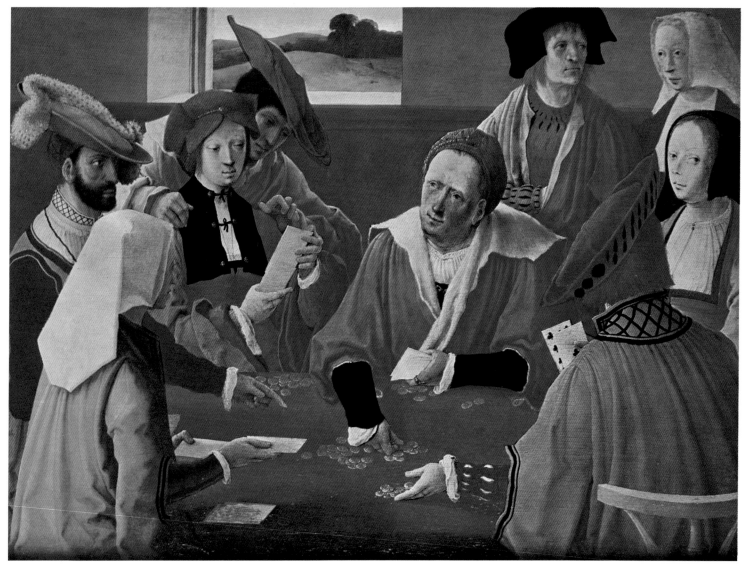

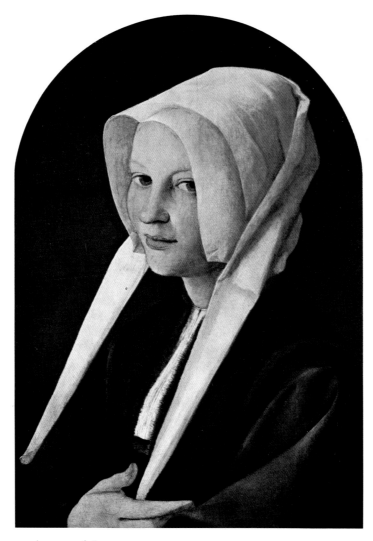

JAN VAN SCOREL (1495-1562). PORTRAIT OF AGATHA VAN SCHOONHOVEN, 1529. (14½ × 11″)
GALLERIA DORIA-PAMPHILI, ROME.

The *Healing of the Blind Man of Jericho* (Leningrad), dated 1531, is remarkable for the capable marshaling of figures, the fine sweep of the landscape and the skillful oppositions of lights and darks. The style in the main is that of the Renaissance, though in the two standard-bearers on the side panels we see traces of the transition from Gothic to Mannerism. This mannerist trend is also evident in his *Last Judgment* altarpiece (Leyden), painted in 1526. Here he obviously started with Italian models in mind, but successfully recast the formal, classical conception of the nude by the impetuous vigor of his brushwork. The side panels represent Paradise and Hell when open, and St Peter and St Paul when closed. But the culminating point of Lucas's mannerist phase was probably the Berlin *St Jerome*, generally assigned to 1516. Granted that the dating of these pictures is accurate, they illustrate a stylistic development ranging from Mannerism to Renaissance realism—which goes to prove once again that Mannerism could be arrived at by way of Late Gothic.

27

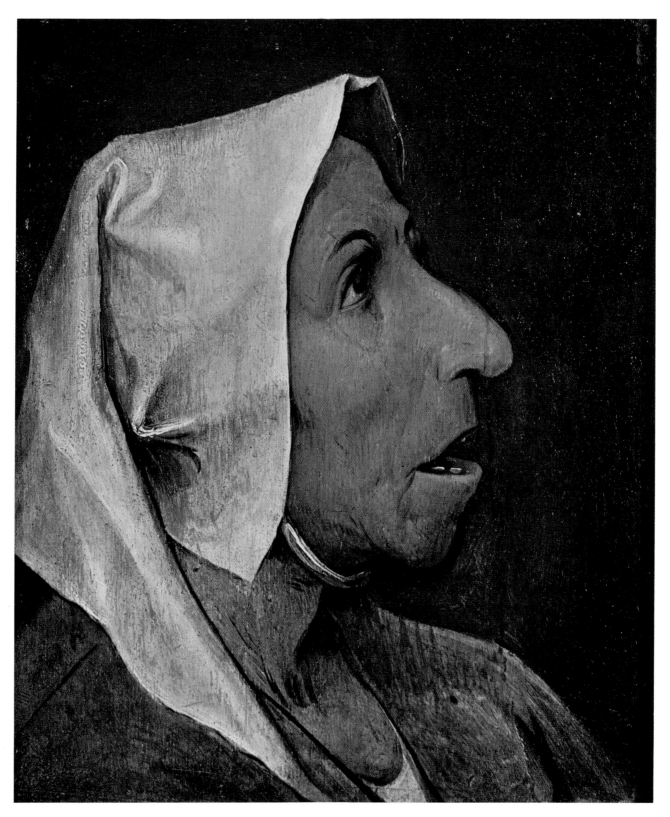

PIETER BRUEGHEL (CA. 1525/30-1569). HEAD OF AN OLD PEASANT WOMAN, CA. 1568. (8⅝ × 7⅛″)
ALTE PINAKOTHEK, MUNICH.

Our knowledge of Brueghel's life is very meager. We know for certain neither the date—some time between 1525 and 1530—nor the place of his birth; probably he came from North Brabant, which forms part of present-day Holland. The earliest mention of him is an entry in the membership rolls of the Antwerp Painters' Guild for the year 1551. In 1552, going by way of Lyons, he traveled to Italy where he is known to have resided in 1552-1553. Back in the Netherlands, he went into partnership with Hieronymus Cock in 1555, producing landscape drawings which the latter engraved. Brueghel's interest seems to have centered for years on engraving, the bulk of his paintings dating from after 1562.

He made a trip to Amsterdam in 1562 and the following year married the daughter of Pieter Coeck, under whom, according to Van Mander, he had studied painting. From now on he made his home in Brussels, where in 1565 the City Council ordered a painting from him to commemorate the opening of the Brussels-Antwerp canal, but he died in 1569 without having filled the commission.

Success came quickly to Brueghel and his work was much sought after by contemporaries. The most influential Catholic dignitary in the Netherlands, Cardinal Antoine Perrenot de Granvella, eagerly collected his pictures. Niclaes Jonghelinck, a wealthy Antwerp burgher, bought sixteen of his canvases and in 1565 commissioned the series of *Months*, one of Brueghel's finest achievements.

He had many friends in intellectual circles. One of his intimates was the famous geographer and humanist Abraham Ortelius, and in Rome the miniature-painter Giulio Clovio, then at the height of his fame, welcomed Brueghel's collaboration. In his *Descrittione di tutti i Paesi Bassi* written in 1567, two years before Brueghel's death, Ludovico Guicciardini refers to him with much respect. Vasari gives a detailed account of several prints made after Brueghel's designs and Dominicus Lampsonius (1572) voiced his admiration of his work. His friend Ortelius, hailing him as the greatest artist of his age, contrasted his bold originality with the stylizations of the mannerists. In 1604 Carel van Mander, in his *Schilderboek*, published the first biography of Brueghel. By the 18th century, however, his reputation was at its lowest ebb; the great French connoisseur Pierre-Jean Mariette was alone in appreciating his genius, as was Baudelaire in the 19th century. Brueghel began his return to favor about 1890 and today he is one of the most popular of all Old Masters.

In the absence of firsthand documentary material, great artists' lives become the helpless prey of legend-mongers; Brueghel's is a typical instance. Because peasant life and carousals were stock themes of his paintings, it was taken for granted that he too was of peasant extraction. Then, more recently, when light was thrown on his familiarity with the Italian Renaissance, it was promptly assumed that Brueghel was a humanist of the Platonic school. But what do the paintings themselves tell us about the man? They tell us that he painted scenes of peasant life because he was an original artist of a refined yet lusty temper, highly conscious of his powers; they tell us, too, that, for all his intimacy with it, he reacted against the Italian Renaissance. Given the period and place in which he lived, Brueghel's art necessarily owed something to mannerism (an

important point first made by Max Dvořák), but it was more in the nature of a counter-blast to it. Even if he is not the "anthropologist and social philosopher" that Aldous Huxley (in *Along the Road*) sees in him, he is certainly a poet, adept in comedy and tragi-comedy, as well as a shrewd assessor of national character in the Netherlands (Friedländer). And, as we shall see presently, there can be no question of separating form and factual content (the "human comedy") in his work.

Brueghel's contemporaries, so Lampsonius informs us, looked on him as a kind of improved edition of Bosch, and this view, in the main, is still current. What Bosch had done—and he was the first artist in the Netherlands to take this step—was to paint religious and edifying subjects without the least regard to the long-established traditions of ecclesiastical art; he went out of the church, mingled with the people of his native Flanders, and voiced the feelings of the common man. So far as is known, Brueghel never painted a single picture intended to figure in a church, thus radically departing from a tradition that went back to Van Eyck; in this he took a liberty whose only precedent was that of Bosch. To Bosch, too, he owed his handling of color, in particular a nicety of tonal values brought out by contrasting touches of bright, pure hues. Unthinkable without Bosch is his way of patterning the composition with tiny figures arranged, not in depth, but on the surface—and this despite his thorough knowledge of perspective.

This, however, is not to say that Brueghel merely carried on and perfected the art of his great predecessor. Rather, he followed his own bent. Bosch had peopled the workaday world with visions of saints and demons; Brueghel left them out altogether, painting nature and daily life without any celestial or diabolic interventions, yet imparting to the passing moment an accent of eternity. Bosch, too, had treated nature as ever-present in man's daily life, but with an eye to stressing everywhere the conflict between good and evil. Brueghel, on the contrary, takes a broad, synthetic point of view of good and evil, thanks to his wider sympathy with human nature and the world around him, even its least pleasing elements.

A picture by Brueghel—in this he follows Bosch and medieval tradition—presents itself as a sequence in time, as against the Italian conception of a sequence in space rendered by perspective. But with Brueghel this chronological arrangement acquires a new efficacy owing to his presentation of the motifs as successive acts in a comedy, following each other like the happenings of a day. It was not from Bosch that he got this notion of an actuality without transcendence; it was Brueghel himself who, thanks to the climate of his time, achieved a new sense of reality, of the "mechanism of the world," as it then was called. This new viewpoint owed much to the Italian Renaissance, but even more perhaps to the typically Nordic conception of what Luther called the "*servum arbitrium*," i.e. the total subordination of human will to the inscrutable designs of Divine Providence. In this respect, then, Brueghel's art may be considered as a synthesis of the Middle Ages and the Renaissance, of the Reformation and the science of nature, of the moral life and freedom of thought. A child of the Middle Ages, Brueghel heralded the dawn of modern times.

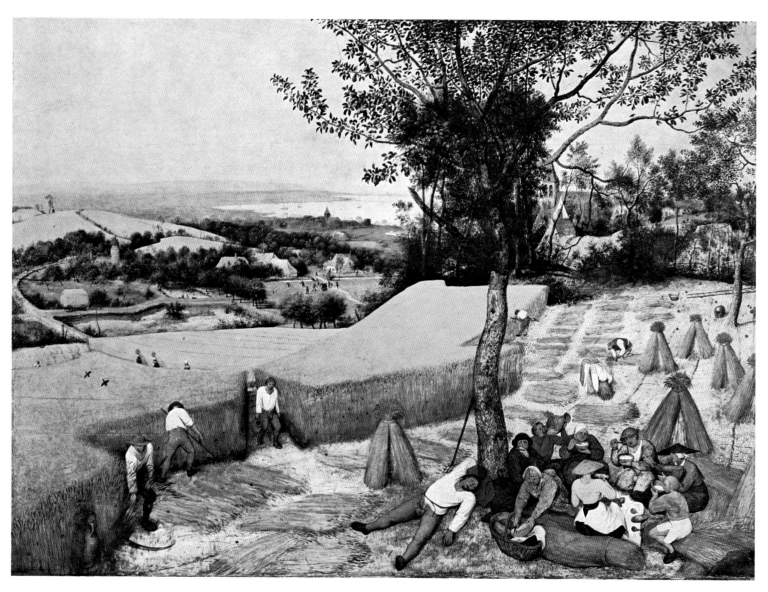

PIETER BRUEGHEL (CA. 1525/30-1569). THE HARVESTERS, 1565. (46½×63¼″)
BY COURTESY OF THE METROPOLITAN MUSEUM OF ART, NEW YORK.

There is another antinomy in his art. Though patronized by Cardinal Granvella and the Emperor Rudolph II, Brueghel again and again portrayed the sufferings of the victims of catholic and imperial persecution in the Netherlands. Hence the stress usually laid on his friendship with Ortelius, who sympathized with the so-called "libertines" or Anabaptists, regarded as heretics by orthodox Catholics. At this time patriots all over the Low Countries were rallying against the Spaniards and beginning the fight for independence; so there is some justification for reading anti-Spanish —in other words patriotic—intentions into his pictures. This is borne out by a passage in Van Mander's life of the artist: "As some [of his drawings] were too biting and sharp, he had them burnt by his wife when he lay on his death-bed." It is impossible to come

to a definite conclusion on the matter, but there is certainly no question that Brueghel's social satire, far more pointed and more daring than that of Bosch, was hardly likely to be appreciated by those responsible for the tragic plight of the Low Countries. Or was it simply that they took pleasure in the spectacle of others' sufferings, like the Roman aristocrats of the next century who so gleefully collected the low-life scenes painted by the "Bamboccianti"?

As suggested above, comedy is implicit in Brueghel's form no less than in his themes. His is neither the polished form of the Italians nor the grotesque extravagance of Bosch. Indeed it might be said that he lays little stress on form. Yet if we inspect his figures closely, we find that they are carefully built up in terms of volumes and adjusted to a geometric structure of cones, cylinders and the like. The results are, first, that their inherent energy as constructive elements of a whole is intensified; and, secondly, that their expressive power as individual forms is attenuated in the interest of compositional unity.

Precisely because he passes no judgment, moral or aesthetic, on the persons he depicts, Brueghel attains a reality beyond good and evil, beyond the beautiful and the ugly, the noble and the base. Human life writ large obliterates the individual and his personal aspirations; personality is submerged in anonymity, faces express neither joy nor fear, but dwindle to moon-like masks. There is here no intimation of destiny, for that is something operating from outside; each man bears his own fate within himself. Brueghel's attitude is that of a disillusioned observer, perhaps embittered, but assuredly resigned to the vagaries of the human situation. This impersonality inevitably led up to the genre scene; indeed both the *Procession to Calvary* and the *Conversion of St Paul* might be described as such, so completely are the figures of Christ and Paul merged into the mass of secondary figures. The "hero," idealized and set on a pedestal by the Italians, was eliminated from the field of art in Brueghel's work, and the historical picture shared his fate. Tolnay has pointed out the striking parallel between Brueghel's hordes of undistinguished figures and a passage in the writings of Sebastian Franck, the German freethinker, who died while Brueghel was still a boy: "Life is one and always the same on this earth. Every man is but a man. When we see a man as nature made him, we see all men."

As far as is known, Brueghel began his career by drawing and painting landscapes. In his quaint but telling style Van Mander writes: "On his journeys Brueghel did so many views from nature that it was said of him that, when he traveled through the Alps, he had swallowed all the mountains and rocks, and spat them out again, after his return, on to his canvases and panels." His pictures confirm these words. As a landscape painter, he aimed at an exact representation of reality, neither prettifying nor idealizing what he saw. Thus while a drawing in Berlin (1552) shows a featureless, quite ordinary mountain, another in the Louvre, dated 1553, shows a majestic, rugged mountain looming above a plain, with storm-clouds gathering overhead. When he was in Italy Brueghel must have seen one of those drawings by Leonardo which seem like pitched battles between natural elements. The earliest dated landscape painting (1553)

is *Christ appearing to the Apostles at the Sea of Tiberias*; here the figures are so small that they almost pass unnoticed in the landscape, which, however, still owes much to Patinir.

Far more original is the *View of Naples* (Galleria Doria, Rome), in which the scene is viewed from above and forms are so well adapted to the circular sweep of a mountain range that the breakwater too—rectangular in reality—has become a semicircle. The city is placed far back so as to leave ample room for a fine seascape dotted with boats of various shapes and sizes and for a view of the crowded wharves. The presentation is still topographical, embracing a vast panorama, but the handling of the scene is painterly and strikingly effective.

In 1555 he began work on the *Large Landscape Series*, engraved by Hieronymus Cock. The variety of motifs—trees, mountains, rivers—and the deep spatial recession

PIETER BRUEGHEL (CA. 1525/30-1569). THE NUMBERING AT BETHLEHEM, 1566. (45 ⅝ × 64 ¾″)
MUSÉE DES BEAUX-ARTS, BRUSSELS.

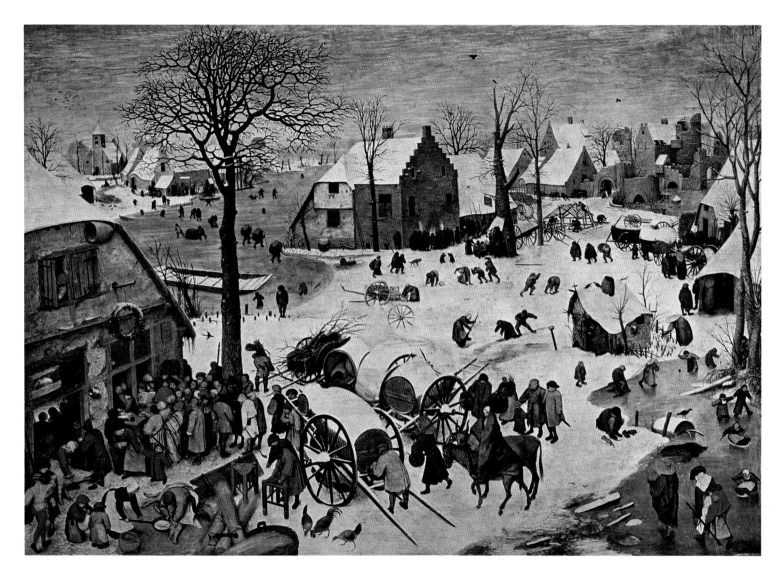

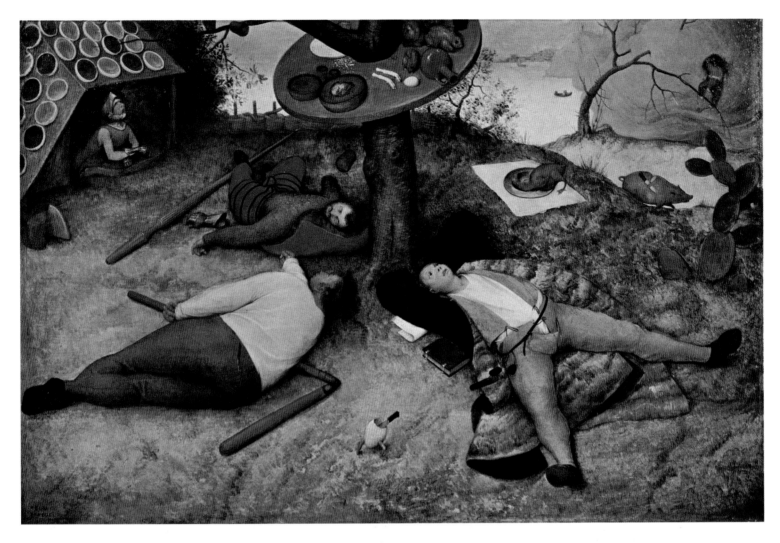

PIETER BRUEGHEL (CA. 1525/30-1569). THE LAND OF COCKAIGNE, 1567. (20½ × 30¾")
ALTE PINAKOTHEK, MUNICH.

testify to the artist's desire to include as vast a prospect as possible. Then, to please his public with a touch of "human interest," he added figures, for example soldiers resting on the march, pilgrims on the way to Emmaus, or the Magdalen.

The expressive tension of the landscapes is stepped up by the colors. The *Fall of Icarus* (Brussels) is a case in point. Far from being the tragic scene suggested by the title, it is a lyrical depiction of a sunlit bay and foreshore. Here a high viewpoint helps to bring out the convexity of the sea stretching into the distance, while a subtle play of light vivifies and individualizes each element of the picture. Quite unaffected by the fate of the young flyer, who is seen sinking beneath the waves in the lower righthand corner of the picture, are the ploughman, shepherd and fisherman, but even more striking is the vast serenity of nature shown in all her smiling beauty. The other side of nature, her elemental fury, is illustrated in the *Storm at Sea* (Vienna). No human figure is visible; driven by the gale, ships are laboring in the troughs of gigantic waves

that weave a sinuous linear arabesque across the picture surface, while gleams of livid light slash the blue-black expanse of sea and sky. This is not so much a representation of nature as the eye beholds her as the revelation of one of her moods.

Occasionally Brueghel forgoes the panoramic approach, as in a drawing at Brunswick, *Village Landscape* (1562), in which the subject is treated as a mere pretext for the rendering, in tiny lines of yellow ink, of the vibration of the light enveloping objects. The more he narrows down his subject-matter, the closer he gets to the life of nature. And it is this perception of the spiritual and eternal present behind the here-and-now that purifies and universalizes his art, and, differentiating him from Bosch and Patinir, links him up—as Van Mander rightly observed—with Titian.

Although the pictures he painted in the last decade of his life (1559-1569) form a group apart, we can trace in them a gradual evolution of his style—as was only natural, considering that the artist was still a relatively young man. The *Fight between Carnival and Lent* (Vienna) and the *Netherlandish Proverbs* (Berlin) date from 1559; the *Children's Games* from 1560. All three have much in common: the distribution of a number of small figures along an inclined plane running up to a high horizon-line, which reduces the problems of space representation to a minimum; a simplified type of composition,

PIETER BRUEGHEL (CA. 1525/30-1569). THE PARABLE OF THE BLIND, 1568. (33⅞ ×60⅝")
MUSEO NAZIONALE, NAPLES.

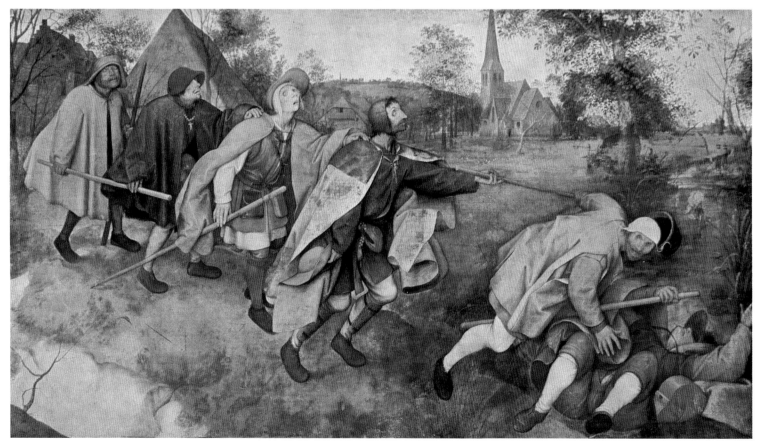

though in the last two pictures figures are grouped diagonally in order to suggest spatial recession. Notable is the union of ground and figures by means of color, and the scaling down of the latter to the aspect of automatons whose comic, apparently pointless antics are a perpetual source of surprise. The sudden beauty of certain figures and bits of landscape stresses the temporal values implicit in the motifs; we seem to be watching a comedy unfolding itself scene by scene.

One of the most remarkable of Brueghel's pictures, the *Triumph of Death* (Prado), differs radically from medieval versions of this subject in that here it is visualized as a pitched battle between the living and the dead—the victory of the latter being assured by sheer numbers. There are dramatic touches such as the bleak desolation of the background and gruesome acts of violence, but these are merely incidental. The message Brueghel sought to convey was one of forlorn resignation: "Such is the human condition, whether you like it or not."

Three major pictures date from 1562. The first of these, the *Fall of the Rebel Angels* (Brussels), is also a meditation on death, a theme which seems to have obsessed the artist at the time. The fallen angels are monsters worthy of Bosch, while the celestial angels are graceful figures carrying out their murderous task with joyous unconcern; the tragic drama of divine reprisal is submerged in comedy. The *Dulle Griet* or "Mad Meg" (Mayer van den Bergh Museum, Antwerp) represents a hag whose greed has emboldened her to visit Hell in quest of plunder. The disproportion between her tall ungainly figure and the Lilliputian creatures swarming around her is a throwback to medieval tradition, but the mordant satire of the scene as a whole, especially the group of shrews cudgeling a hapless pack of devils, is strangely modern in spirit. Presumably the *Two Monkeys* (Berlin) has some symbolic meaning yet to be elucidated. Meanwhile we can enjoy for its own sake this picture of two monkeys chained in a low dark archway opening on a sunlit view of Antwerp and the Scheldt.

We have another type of picture altogether in the *Suicide of Saul* (1562) and the *Conversion of St Paul* (1568), both in Vienna. In each a rugged Alpine landscape lends an epic grandeur to a scene of armies locked in battle or on the march. In a corner of the first we see Saul running himself through with his sword, while in the middle distance of the second Paul has just been thrown from his horse; but these incidents almost pass unnoticed, the artist's interest manifestly lay elsewhere. The *Procession to Calvary* (1564, Vienna) is a biting satire of the callous indifference of the crowd present at the tragic scene. In striking contrast is the delicately sensitive rendering of the little group in the foreground surrounding the weeping Virgin.

In 1565 Brueghel was commissioned to paint the series of *Months*, of which today only five are extant: *January* or *Hunters in the Snow* (Vienna), *February* or *The Gloomy Day* (Vienna), *July* or *Hay Making* (Prague), *August* or *The Harvesters* (Metropolitan, New York) and *November* or *The Return of the Herd* (Vienna). These rank among his finest works. We have seen him as a satirist, tilting at the follies of mankind, the futility of their griefs and joys. But he was a born landscape painter and if there was one thing he held sacred, one thing his satire spared, this was nature. Village

PIETER BRUEGHEL (CA. 1525/30-1569). THE MAGPIE ON THE GALLOWS, 1568. (18 ⅛ × 20″)
LANDESMUSEUM, DARMSTADT.

life in the snow and gloom of winter, the lush exuberance of summertime, the wistful melancholy of autumn—these themes, in his hands, become so many evocations of the very soul of nature. Most popular of these scenes is *Hunters in the Snow,* in which dark silhouettes of peasants and ice-skaters, the descending line of tall bare trees

and the structural perfection of the snowbound landscape give the full measure of his greatness. Broader and vaster is the landscape of the *Gloomy Day*; instead of standing out against the snow, tonal values melt into the prevailing grey, creating a sense of endless depth and distance. In *The Harvesters* the rendering of volumes in the half-reaped wheatfield and the sheaves is singularly "modern," while the figures of the harvesters seem strangely small and frail beside the monumental permanence of nature. Beyond them is a glimmering lake stretching out to the dim horizon. The poetic quality of Brueghel's landscape backgrounds is particularly striking in some slightly later works such as the famous *Magpie on the Gallows* (1568, Darmstadt), where the real theme is the wooded hillside in the foreground, sloping away towards a spacious valley.

Though in the *Numbering at Bethlehem* (1566, Brussels) the subject is given prominence, the landscape is no less fine than in the *Months*. Here there is more, far more, than satire, thanks to the moral and poetic elevation of the scene and the sensitive treatment of the poor folk flocking around the census-taker's table, amongst whom, unnoticed by anyone, is the Virgin.

In Brueghel's final phase we find a shift of emphasis from landscape to figures and individual expression. A new earnestness appears, though he still cannot refrain from an occasional fling at comical humanity, as in the *Wedding Banquet* (Vienna), the *Peasant Dance* (Vienna) and the *Land of Cockaigne* (Munich, 1567). The grotesqueness of the last-named is ingeniously heightened by the bird's-eye perspective and the quaint arrangement of the figures, disposed around the central tree like spokes of a wheel.

Dated to 1568, the year before his death, are *The Cripples* (Louvre), *The Misanthrope* (Naples) and the *Parable of the Blind* (Naples). In the first, the plight of the poor wretches is so poignantly conveyed that the grotesque merges into the tragic. The composition of the second is a masterpiece of simplicity. The picture is a tondo, in which the misanthrope, a somber figure slowly moving across a pale-hued landscape, is painted with illusionist realism. Beneath him the following explanation is inscribed in Flemish: "Because the world is so faithless I am going into mourning." But the world is already taking its revenge: a figure in a glass globe (symbol of vanity) is stealing the purse (symbol of earthly riches) which the misanthrope has been concealing under his voluminous cloak. The last, unquestionably Brueghel's most tragic and pessimistic work, illustrates the Gospel parable of the blind leading the blind. By increasing the number of blind men to six (there are only two in the parable) Brueghel "protracts our tension and fearful expectation of the fall we know to be inevitable for all" (F. Grossmann). And he points the moral of the parable by the contrast between the stumbling progress of the blind and the rock-like stability of the church in the offing.

Thus Brueghel's artistic evolution falls into three phases. After interpreting his responses to scenes of nature, he moves on to satirical depictions of the human comedy, the absurdities of men's private and public lives. And the satire is all the more convincing because he makes us feel behind these the iron hand of destiny. Then in the last phase he reveals the pathos of the human predicament with a poignancy rarely equaled and never surpassed by any other artist.

PAINTING IN VENICE

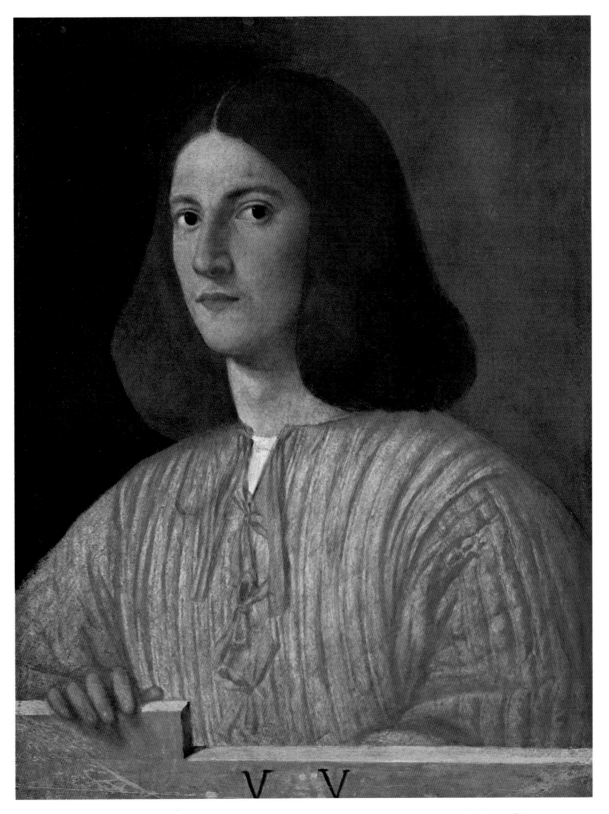

GIORGIONE (CA. 1480-1510). PORTRAIT OF A YOUNG MAN, 1505-1507. (22¾ × 18″)
KAISER FRIEDRICH MUSEUM, BERLIN.

2

FROM GIORGIONE TO VERONESE

FOR an understanding of the development of Venetian painting in the 16th century, we have to take into account various factors other than those of a strictly aesthetic order. The art of the Venetians was relatively untouched by humanism since it had no direct contacts with classical antiquity and, above all, because it stemmed from an outlook on the world very different from that which had prevailed in Florence during the previous century. Mantegna and Giovanni Bellini, it is true, assimilated Florentine art practice and adapted it to the artistic climate of Venice and North Italy in general. Nor must we forget that in the last decade of the 15th century Leonardo had given Florentine tradition a new direction and broadened the painter's field of activity. Before this, man had been the artist's chief preoccupation; henceforth he aspired to include the entire scheme of things in his domain. Ceasing to be a merely functional element of the composition, space was transmuted into landscape and atmosphere and became a living presence. And now that his form lay open to surrounding space, man was no longer an isolated unit but a fully integrated element of the picture. Sponsored by Leonardo and symbolized by his *sfumato*, this ideal was brilliantly realized by the color and light-and-shade effects of the Venetians, and by the new vision of reality implicit in their style. Thus as against the Florentines' insistence on outlines, proportions, structure and perspective, the Venetians saw the world in terms of colored masses, capable of absorbing human figures as well as things into themselves. This was not a Renaissance or a humanist conception in the sense in which these epithets apply to Michelangelo's or Raphael's art. It was, rather, a "modern" conception—as is proved by the fact that until the end of the 19th century it was, with rare exceptions, basic to all European painting.

This form of expression was not solely a creation of the genius of Giorgione and Titian; it linked up with the special conditions prevailing in Venice. At the beginning of the century it looked as if Venice was to come under a foreign yoke, but by heroic efforts she preserved her freedom and her victories fired the enthusiasm of all Italians. In 1544 Paolo Giovio declared that the banner of St Mark was the emblem of Italian liberty and nearly a hundred years later Bernardo Tasso extolled the Venetian achievement. "Is not Venice the shining symbol and consecration of Italian honor? What other light or glory remains to my poor Italy in the darkness of this troubled age? All the rest of us are serfs and tributaries of, I will not say barbarians, but foreign

nations. Venice alone has kept her freedom, and owes obedience to none but God and her own well-framed laws." And, what was still more remarkable, Venice succeeded in maintaining a certain independence even in her dealings with the Papacy and the Council of Trent.

Another noteworthy fact is that—aside from politics—the genius of Venice expressed itself almost exclusively in painting. Florence is as famous for her architecture, sculpture and poetry as for her painting, and, when her fate hung in the balance, diverted her activity to scientific research. Venice, on the other hand, devoted all her energy, and all her wealth, to painting. We describe elsewhere the Europe-wide vogue of mannerism during this period (Brueghel alone was untouched by it). But though Venice dallied with certain mannerist procedures, she never let them get the upper hand—anyhow until after the deaths of Tintoretto and Veronese. The intellectual ferment which led to mannerism hardly affected Venice, whose age-old confidence in Church and State remained unshaken and where, for this reason, an atmosphere of buoyant optimism persisted longer than elsewhere.

Moreover the fact that they had kept their independence enabled the Venetians to appreciate, better than other Italians, the religious and artistic aspirations of the Germans and the Netherlanders. Dürer, Bosch and the northern engravers were familiar to Venetian artists and collectors; indeed it is not going too far to say that 16th-century Venetian painting reconciles the traditions of Florence with those of Bruges.

No Venetian artist, not even Titian, was an intellectual and to regard the Venetian painters as in any sense deep thinkers or philosophers would be to misjudge them. But certain affinities between the ideas of the school of Padua (the university town of Venice) and Venetian painting show that both thinkers and painters were in their respective manners—intuitively in the case of the painters—trying to express the *Weltanschauung* of the age. Although it is impossible to draw a hard-and-fast line between Florentine Platonism and the Aristotelianism of Padua and Venice, owing to the constant interactions between these schools of thought, there can be no doubt that the latter prepared the way for the "science of nature" that held the field at Padua during the 16th century. As early as its first decade the conception of "Immanence" was in high favor; sensation was regarded as the fountainhead of knowledge, more basic to it than even form, with the result that ever-increasing attention was directed to the "dictionary" of nature. The dialogue of Pietro Bembo (1470-1547), *Gli Asolani*, and *La Vita Sobria* by Alvise Cornaro (1475-1566) illustrate this attitude. Each in his own way stresses the benefits of living in the country and sees in nature a source of infinite delight. The steady increase in the number of country houses, the loving care with which they were planned and decorated, testify to the desire of the Venetians to escape from the artificial life of the city and return to nature. Echoes of these ideas can be found in various treatises on art, notably those of Pietro Aretino (1492-1556), Paolo Pino (first half of the 16th century) and Ludovico Dolce (1508-1568).

In his treatise published in 1548, Pino stages a meeting between himself and some beautiful women and the discussion centers on the best method of deciding which is

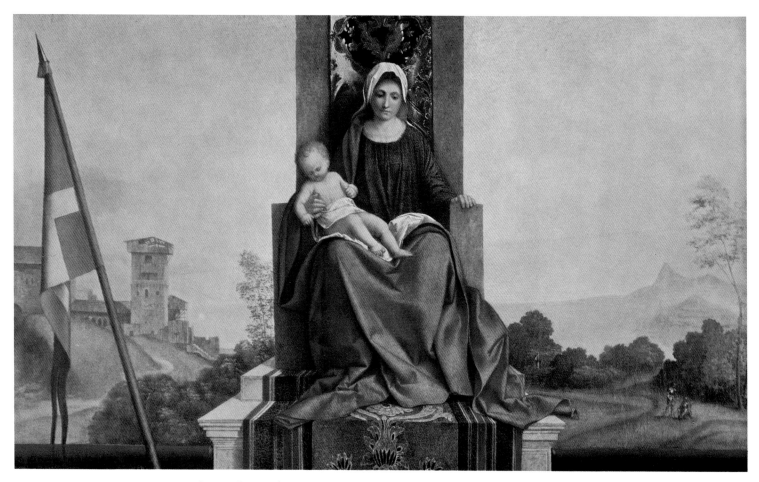

GIORGIONE (CA. 1480-1510). MADONNA AND SAINTS (FRAGMENT), AFTER 1504.
CHURCH OF SAN LIBERALE, CASTELFRANCO.

the most beautiful, that is to say on a problem of pure aesthetic sensibility. When a Florentine, Leon Battista Alberti for example, sought to work out a theory of art, his chief concern was to discover a scientific basis for it. Whereas the Venetian writer Dolce, instead of investigating, like the Florentines, the laws of ordered pictorial architecture according to perspective, declared (in 1559) that the basis of painting is something beyond "order" and that the arrangement of natural motifs in a picture should not seem studied or contrived but, rather, the work of chance. Pino, moreover, demurs at any law of proportions, holding that figures in a picture should be in movement and movement is independent of any such abstract law. Whereas the linear, plastic style of the Florentines called for meticulous finish, Michelangelo rebelled against this cult of finish—that was one of the tragedies of his stormy life. Aretino, too, knew that a smooth perfection destroyed the vitality of the image and praised Tintoretto's hasty execution, since it enabled him to give freer scope to his creative urge.

Alberti had formulated the principle of "composition"; Pino and Dolce replaced it by the theory of "invention"—which in some ways assimilated the artist's vision to the storyteller's role. The Venetians saw no distinction between form and content

in the work of art since both were merged into their new conception of pictorial reality. Similarly they tended to rule out any distinction between form and color. To their thinking it was color that brought figures to life, effected contrasts between light and shade and determined perspective relations. But the contrasts should not be violent, nor the color over-strong. Flesh-tints, above all, should be subdued, not too bright, the colors being handled in such a way as to give the texture of the skin a gentle radiance. These methods corresponded to a sensuous vision of reality, essentially human and intuitive, irreducible to any logically precise definition. Alberti had formulated an aesthetic; the Venetians relied on preferences of taste.

This relative indifference to art theory (as compared with Florence) was fundamental to the new way of seeing that arose in Venice. Implicit in the humanists' ideal of due proportion and perspective representation of space was a residue of the medieval and Platonic notion of transcendence. Nothing of this existed in Cinquecento Venetian art. Ordered beauty and pure form were replaced by the splendors of life at its most luxurious; mysticism by ritual observance. *Maestria* of touch and color conjured up the whole gamut of reality, almost without discrimination, thanks to a happy concord between the senses and the mind—thus ushering in the modern vision of reality.

GIORGIONE Although no exact information as to the life of Giorgio da Castelfranco, commonly called Giorgione, is forthcoming, one thing is certain: that he was the originator of the Venetian style of painting as we see it in the work of Titian, Sebastiano del Piombo and many others. Nothing definite is known about his early training or the chronology of his works. He died of the plague in 1510, in his early thirties.

The *Madonna and Saints* in the Cathedral of Castelfranco (near Treviso, in Venetia), probably painted a little after 1504 for Tuzio Costanzo, is a very early work. One of the striking things about it is the loftiness of the throne, whose top is out of sight, rising beyond the upper edge of the picture towards the zenith. The Madonna and the two saints stand out clearly against the background formed by the throne (behind which is a landscape prospect) and a sort of wall draped in red velvet. Though perhaps a little unsure, the composition is beautifully conceived, while the elongation of the figures, the elegance of their postures and even the artificial character of the separation between figures and landscape reveal the poetic quality of the young artist's genius. Here we find nothing of the austerity or deep religious fervor of Giovanni Bellini; the pervading mood is one of languorous enchantment and the figures, devoid of any plastic values, have a curiously dreamlike remoteness. Notable is the expression on the Child's face (this was something new in religious art) and the softness of the colors, giving Him the naïve charm of a very human babe. The throne, too, has none of the elaborate carvings dear to Bellini; it consists solely of color zones spread with richly patterned rugs. Drawing inspiration from Carpaccio, Giorgione lavished a wealth of spellbinding colors on this picture. The landscape, like that of the two small scenes, *The Trial of Moses* and *The Judgment of Solomon* in the Uffizi, differs from Giovanni Bellini's landscape backgrounds; less carefully built up and elaborate, it has a melting suavity of color, reminiscent

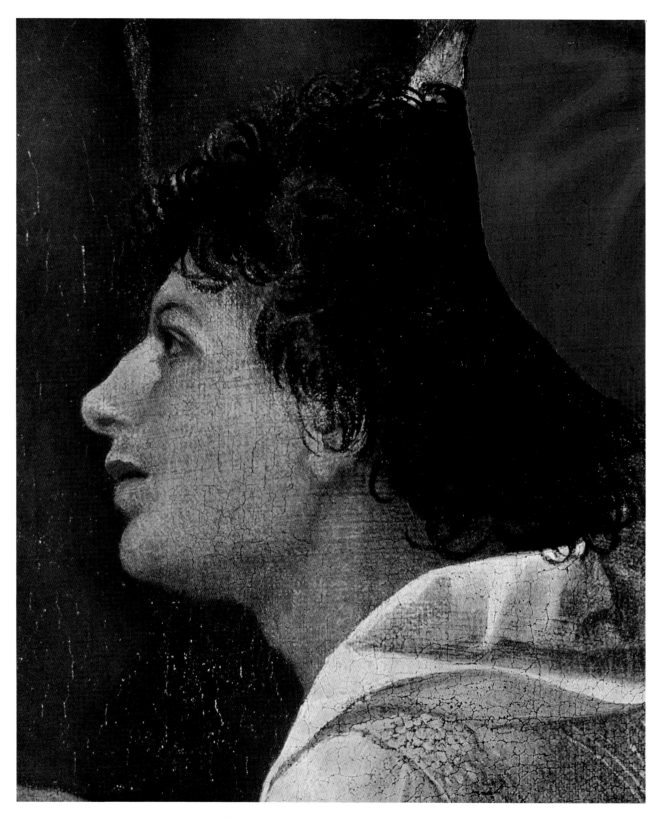

GIORGIONE (CA. 1480-1510). THE THREE PHILOSOPHERS (DETAIL), 1506-1508.
KUNSTHISTORISCHES MUSEUM, VIENNA.

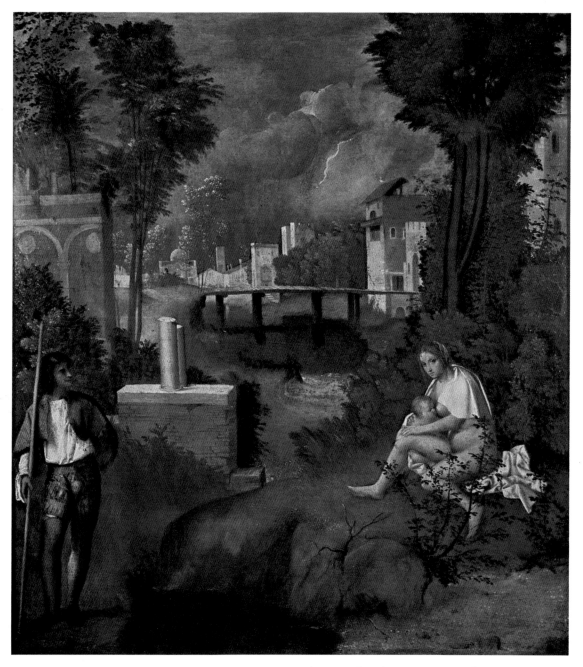

GIORGIONE (CA. 1480-1510). THE THUNDERSTORM, CA. 1505. (30 ⅝ × 28 ¼ ″) GALLERIE DELL'ACCADEMIA, VENICE.

of the painting of Northern Europe. But it is in his three major works, the *Thunderstorm* (Venice), the *Three Philosophers* (Vienna) and the *Sleeping Venus* (Dresden) that the tendencies adumbrated in the *Madonna and Saints* reach their culmination. None of these three pictures has a well-defined theme, whether religious or philosophical. The *Venus* was for Giorgione merely a pretext for painting a woman in the nude, and he treated the *Three Philosophers* and the *Thunderstorm* as "free fantasies." When in Venice (1541-1542) Vasari saw Giorgione's frescos—no longer in existence—in the

Fondaco dei Tedeschi, he admitted that he could make nothing of what they represented. And in evaluating his art, we do well to bear in mind this absence of any traditional, identifiable theme; also the fact that, apart from certain "show-pieces" made for churches, the Ducal Palace and the Fondaco dei Tedeschi, Giorgione painted chiefly for private persons. Ferriguto, an authority on humanist literature, suggests that Gabriele Vendramin, Taddeo Contarini and Girolamo Marcello who, between 1525 and 1530, owned the three pictures named above probably commissioned Giorgione to paint them,

GIORGIONE (CA. 1480-1510). THE THREE PHILOSOPHERS, 1506-1508. (47 ⅝ × 55 ¾ ")
KUNSTHISTORISCHES MUSEUM, VIENNA.

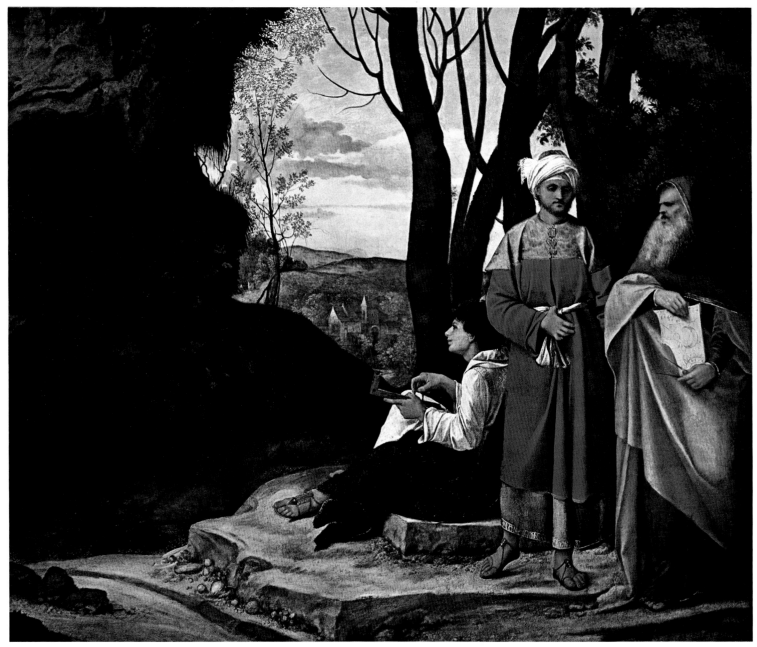

when they were all quite young men. This is borne out by what Vasari says: that Giorgione worked for "three young members of the Venetian aristocracy," friends whom he met at parties and musical evenings.

X-ray examination has shown the way in which Giorgione went about these pictures. In the *Thunderstorm* are two figures whom Marcantonio Michiel (an early authority on Giorgione) described as "a soldier and a gypsy," but they might easily be named quite otherwise, since the "soldier" is unarmed and the "gypsy" so called simply because she has nothing on. X-rays show that the artist originally painted a woman going down to the river to bathe at the spot where the soldier stands now. Obviously if he had started out with any definite program in mind, Giorgione could not have made such a drastic alteration. The reason for it was purely aesthetic; the composition was better balanced by the figure of a standing man at this point than by that of a woman. Also, by so doing he added a touch of mystery that would have been lacking in a "straight" picture of two women bathing. Thus Giorgione's thematic material was a product of the free imagination; the *Thunderstorm* was painted for the pleasure it gave the artist in creating it and his friends in looking at it.

In the *Three Philosophers*, too, X-ray examination has revealed some interesting pentimenti; for example, the central figure was originally a Moor and those on the right and left were likewise exotic types, one wearing a big diadem, the other an oriental hat. As the Magi came from the East and one of them was a blackamoor, it may be that Giorgione's original intention was to depict them on their way to Bethlehem. True, there was no iconographic precedent for this—all "Nativity" pictures showed the Kings of the East at or near their journey's end—but Giorgione may have been inspired by an apocryphal text in which the three kings were described as "addicts of celestial mysteries," that is to say astrologers, watching for the promised star. In any case he totally discarded any such allusion in his final version, and merely painted three—unspecified—philosophers. But we must remember that at this time, as Ferriguto has pointed out, the three chief schools of philosophy in vogue at Venice were medieval Aristotelianism, Averroism and the new "science of nature." So it seems clear that Giorgione wished to symbolize medieval Aristotelianism by the bearded old man, Averroism by the Oriental, and the new philosophy by the young geometrician.

Giorgione completed neither the *Three Philosophers* nor the *Venus*; that was left to Sebastiano del Piombo and Titian. But there are grounds for thinking that his death was not the reason for these pictures' being left unfinished. They are not in keeping with his final style and, in any case, he failed to complete several other works. He began a picture without knowing exactly what form it would take, and improvised as he went along. And such was his impatience with the drudgery of manual labor that he often left the finishing of it to some brother artist who understood what he was after. This, as we have seen, was also a habit of Leonardo and Michelangelo who, like Giorgione, were in many respects precursors of modern art. It was by this disdain of "finish" that they disowned the medieval identification of the artist with the artisan and emphasized the fact the former created more with his mind than with his hands.

Since, as Giorgione saw it, the "subject" was merely a vehicle for expressing his way of seeing and feeling, he was naturally led to bring his figures into close association with their setting and, as in the pictures we have been discussing, to express his personal reactions as much by the landscape as by the figures. In the *Thunderstorm* we have, for the first time, a landscape with figures instead of figures with a landscape. When an artist takes for his field not only man and the works of man, but nature as a whole, he cannot enclose the human figure in a contour-line that isolates it from surrounding space. On the contrary, he has to create figures capable of being immersed in atmosphere and acquiring from it the modifications that light and shadow bring to bodies. But Giorgione showed some hesitation in choosing between closed and open forms. Giovanni Bellini had taught him to appreciate the beauty and elegance of the circumscribing line, and the splendid oval of the Dresden *Venus*, though it belongs to a world of dreams—so magical is the play of light—was still a closed circuit. But by the time he painted the "soldier" in the *Thunderstorm*, Giorgione had moved towards purely pictorial form, unenclosed and treated sketch-wise.

What we have named purely pictorial form and "unfinish" are two aspects of a style that holds a well-nigh perfect balance between imagination and perception. Giorgione was careful not to define his themes because he wished to give free play to his emotions and imagination; to modify his subjects as the fancy took him. Hence his brilliant improvisations and his practice of regarding as completed, works which might at first sight look unfinished, provided they fully corresponded to his inner vision.

Thus Giorgione's painterly imagination and his sense of the oneness of things led him to open forms, to reject the limitations of the finite and even to view drawing in terms of color. It also led to the expression of states of mind rather than of specific emotions. Nor must we overlook his sensuality, a sensuality free from any sense of sin though curbed by an almost superstitious awe of nature. For Giorgione's art stems from a feeling of participation in all life, an instinctive not an intellectual response, and a poetic contemplation of the universe. Hence that dreamworld in which his figures have their being, the rapt entrancement of their faces, half asleep or lost in wandering thoughts, and the gentle light that bathes them, the light of that enchanted hour when nature is just awakening or on the verge of sleep. In his portraits, too, we see the same magical transfiguration, for example in the Berlin *Portrait of a Young Man* and in the Brunswick *Self-Portrait*.

Finally mention may be made of a problem perhaps never to be solved, that of Giorgione's activity during the last two years of his life. The Dresden *Venus* is probably contemporary with the frescos of the Fondaco dei Tedeschi (finished in 1508). But some pictures traditionally ascribed to Giorgione seem to belong to a rather later phase; we have in mind chiefly the *Concert champêtre* (Louvre) and the *Concert* (Pitti). These works are certainly by his hand, as is proved not only by the style but also by their depth of feeling and that dreamlike atmosphere which, while characteristic of Giorgione, was not achieved by Titian until a much later date. In these final works we find a new quality of emotion, a sublimation as it were of his creative personality.

TITIAN We will begin with a few facts that may help to the understanding of Titian's place in the evolution of European art. In 1508 Giorgione and Titian were still young men, rich in promise for the future, and the former, without being the acknowledged master of the Venetian School, was the artist to whom above all his generation looked for guidance and inspiration. The frescos he and Titian did together in the Fondaco dei Tedeschi have always been regarded as the starting-off point of the new style of painting described above. Barely two years later, in 1510, Giorgione died; Titian was destined to outlive him by sixty-six years.

Until quite recently it was assumed that the two artists were practically contemporaries; the current opinion is that Titian was Giorgione's junior by ten years. But, in view of the conflict of evidence on the subject, it would be rash to draw any conclusions from the supposed age difference.

Born at Pieve di Cadore in northern Venetia, Titian came of a family renowned for its prowess in the field of battle. Michelangelo, too, came of a near-noble family and he too lived to a great age (a little less than Titian's, however), reaching the zenith of his powers late in life, when he was a weary, soured old man. Though not directly bearing on their art, this longevity may suggest how it was that these two men came to be precursors of modern art. For significantly enough, it was towards the end of their lives that their paths tended to converge. Michelangelo's classical, humanistic tendencies are evident in his early *David*, whereas Titian's first dated work, the frescos in the Scuola di Sant'Antonio at Padua (1511), far from having any kinship with classical art, is full of dramatic movement and juvenile brio. Indeed what differentiates his work from Giorgione's is precisely a tendency to dramatize reality so as to make it more "alive." However, at the height of his renown, Titian had to face the charge of not being able to draw as well as the Florentines. As a result he applied himself to learning the secret of Michelangelo's draftsmanship—with untoward consequences, since an exact rendering of the model cramped his natural style, which was essentially allergic to classical form.

Still it would be a mistake to call Titian an impressionist; that would certainly be to overstate the case. The art he aimed at, which had little in common with that of the classicists, was of a social, not to say imperial order; Titian's truth was an actuality seen through aristocratic eyes. We may find it difficult to subscribe without demur to an ideal of this kind; Brueghel's peasants seem nearer to us today than does the equestrian portrait of the Emperor Charles V. Yet we cannot shut our eyes to the grandiose role played by that great monarch in world history. The world he personified, which he saved from anarchy and united under his rule, found its befitting style in the art of Tiziano Vecellio, Count Palatine and Knight of the Golden Spur. Once they discarded the conception of the artist as an artisan, the Florentines had realized that by grace of their genius such men as Leonardo, Raphael and Michelangelo were entitled to a high place in the social order. But it was left to Titian to be the peer of princes and emperors. To have a portrait of oneself by his hand was a patent of nobility; a "Pietà" by him was tantamount to a social "indulgence," and a "Venus" to a proof of sensual

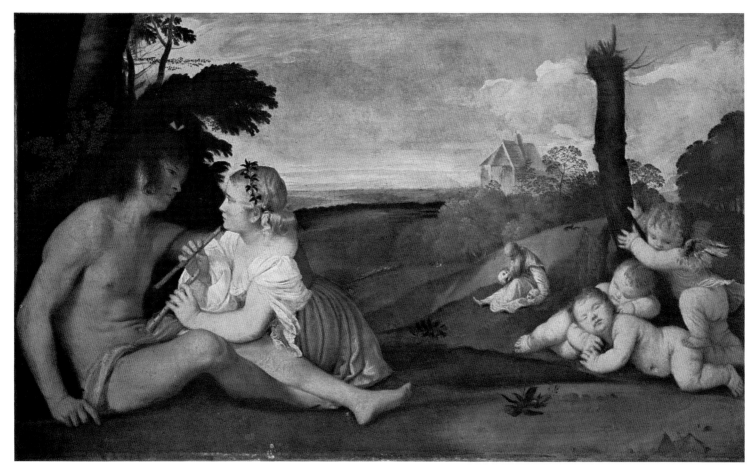

TITIAN (1477/87-1576). THE THREE AGES OF MAN, CA. 1515. (41¾ × 71½″)
COLLECTION OF THE EARL OF ELLESMERE, NATIONAL GALLERY OF SCOTLAND, EDINBURGH.

refinement. If he so generously satisfied the wishes of his patrons, this was because his own tastes were the same as theirs, and because he had a unique knack of bringing their painted forms to life. He could treat with foreign monarchs from the neutral ground of Venice and paint the French king no less readily than the Emperor Charles V and Philip II of Spain. When in 1513 Leo X suggested he should come to Rome he declined the offer. He had not yet won his spurs and he guessed that like Sebastiano del Piombo he would be forced to truckle to the Holy See. When twenty-two years later he went to Rome he was famous throughout Europe and he was accorded Roman citizenship.

On Giovanni Bellini's death in 1516 he was appointed official painter of the Venetian state and began to work for Alfonso I of Ferrara; in 1523 he became painter to Marquis Federigo Gonzaga of Mantua, thereafter to the Dukes of Urbino and the House of Farnese. In 1530 at Bologna he painted the first portrait of Charles V, who invited him to Augsburg for the Diets of 1547, 1548 and 1550-1552. He was the first artist to have a sort of publicity agent—for this in fact was the role of Pietro Aretino, who sent a steady stream of letters to all the great personages of the day, partly to further his personal interests but also to make known the genius of his painter friend.

In 1531 Titian settled into a house in the north of Venice, in the district called Birri Grande. From his new home he could see the Dolomites, the rugged mountains he had so often roamed as a boy, in the far distance. His garden became famous and was a favorite resort of all distinguished visitors to Venice. In 1540 Titian invited to his house the writer Priscianese, along with other intellectuals, for the August 15 holiday. His guests duly admired the master's paintings, then the garden; at sundown dinner was served on the terrace to the accompaniment of music and singing by youths and pretty women in gondolas weaving over the lagoon. This shows that Titian was by now a man of independent means and assured position. He could rub shoulders without constraint with princes, kings, the Emperor and the Pope himself and paint with equal self-confidence the works of piety they commissioned and the decorations of their bed-chambers. He passed no judgment on the subjects he depicted but devoted himself wholly to presenting them with the utmost vitality and to the most grandiose effect. And with his superb color, spiritual penetration and abounding vigor he created as it were a synthesis of the many-sided life of the age.

In the frescos of *The Life of St Anthony* (1511) at the Scuola di Sant'Antonio in Padua, we can see that already Titian had completely shaken off Giorgione's influence. Here there is nothing of the romantic, dreamy languor of his predecessor but a gift for direct narrative seen at its best in the scene of the *Miracle of the New-born Child*. There are a good many figures, but grouped in such a way that the child seems isolated in the center of the composition, visual and psychological pivot of the scene. Forms are brought forward to the surface but that surface is deepened and filled with movement by the juxtaposition of the figures. There is a well-marked distinction (as in Giorgione) between full and empty spaces, the latter suggesting illimitable distance. But most striking of all is the vigor of the color, stepped up by sharp contrasts between light and dark to an extent that would have been impossible with chiaroscuro. The figure of the elegant young man whose dark complexion is foiled by a light-hued cloak is a stroke of genius. Dramatic though it is, the scene has a wonderful serenity. In a different vein is the fresco whose theme is a jealous husband stabbing his wife. This purported to show "St Anthony healing the wounded woman" but Titian relegated the healing to the background, placing the act of violence in the forefront of the scene. Movement is stressed by a foreshortening of the fallen woman's body and the lifted dagger, and the artist shows much skill in suggesting action, without actually showing it, by the man's uplifted arm.

In this very early work we find what were to be the characteristics of Titian's art: free rendering of gestures, intricate composition, rich color orchestration, vital actuality, contrasts of light and dark, highlights on figures. But though in the Padua frescos he turned away from Giorgione's themes he reverted to them subsequently— in, for example, the *Three Ages of Man* (Edinburgh) and *Sacred and Profane Love* (Galleria Borghese, Rome). The far-flung landscape, the nude or draped figures, the pure, brilliant colors saturated with light fully justify the vast popularity of these noble pictures. Yet though motifs and colors derive from Giorgione, Titian has failed

to impart to them the singular poignancy infusing Giorgione's art. He responds to the beauty of human forms and depicts it to perfection, but he cannot invest them with the glamour of a dreamworld—because he is no dreamer.

The Uffizi *Flora* is typical in this respect. There is no landscape, no aura of mystery to distract attention from the physical charms of the young woman, a blonde beauty whose opulent forms tell out delightfully against a uniform background. Botticelli had called on tall, willowy figures to set off his subtle, sinuous line. But Titian found in an amply molded, fair-haired type of womanhood the perfect medium for his rich, effulgent color.

Three mythological scenes fall into the same category. Painted for Alfonso d'Este, they are titled *The Worship of Venus* (1518-1519), *The Bacchanal* (1520), both in the Prado, and *Bacchus and Ariadne* (1522-1523) in the National Gallery, London. Noteworthy in the first of these three works is the effect of restless, exuberant movement conveyed by the frolicsome children, the gay, flower-like profusion of the flesh tints. In the other two pictures, too, there is much animation—some of it, one cannot help thinking, rather purposeless—but the charm of the landscape and colors fully justifies these aberrations, if such they are.

The grandiose expressive power of the *Assumption of the Virgin* (1516-1518), painted for the Church of the Frari in Venice, shows Titian in a different mood. Raphael had succeeded in creating a unity between earth and sky by means of plastic values; Titian does the same thing by means of movement. Despite the fullness of the Virgin's form she soars effortlessly heavenwards, borne aloft by an inner force that gives her body a sinuous movement, harmonizing with the attitudes of the two groups of apostles at the bottom of the picture. A feverish unrest pervades the scene, while the grey-blue of the air behind the apostles melts into the orange-yellow sheen of the celestial regions towards which all are gazing rapturously. Though anything but a mystic, Titian has evoked the scene as vividly as if he had seen it with his own eyes. And it is a token of his total mastery of his means even at this relatively early stage of his career that with light, color and movement, he could body forth his imaginings with such complete verisimilitude.

Light and color effects are even more emphatic in the Ancona *Virgin in Glory* (1520). Here, too, no distinction exists between earth and heaven; in the distance we have an enchanting glimpse of the lagoon, while in the foreground rises the stately figure of St Francis—one of the first of Titian's figures to be imbued with that profound spiritual dignity whose presence makes itself felt in so many of his portraits. In 1522 he painted a triptych for the church of Santi Nazaro e Celso in Brescia; whereas the light effect in the central scene is wholly admirable, one of the side panels—that representing *St Sebastian*—must be written down a failure; here Titian tried to imitate Michelangelo, with lamentable results.

He worked seven years (1519-1526) on the *Pesaro Madonna*, in which he employed the form of composition best suited to his handling of color, light and movement. This involved an unusual placing of the Virgin, well on the right, so as to provide for more

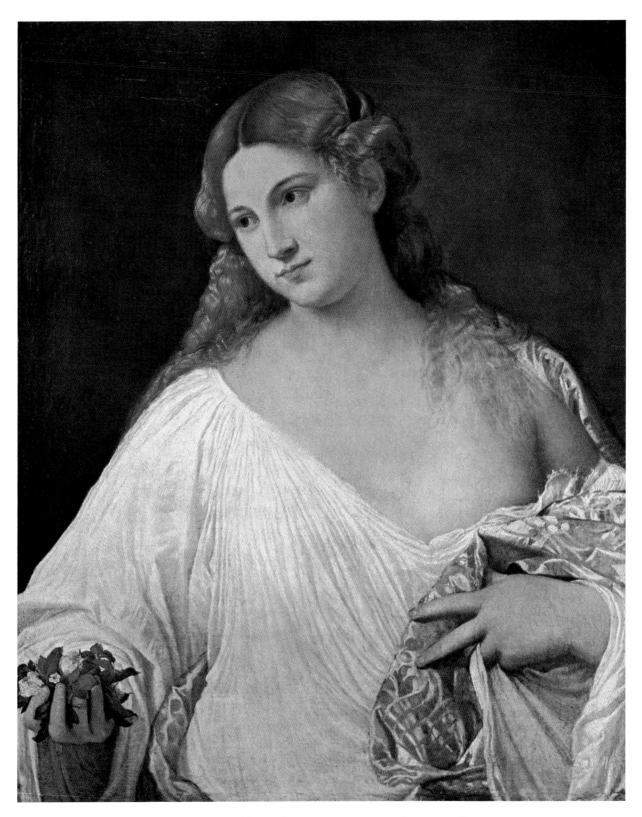

TITIAN (1477/87-1576). FLORA, CA. 1515. (31 × 24¾″)
UFFIZI, FLORENCE.

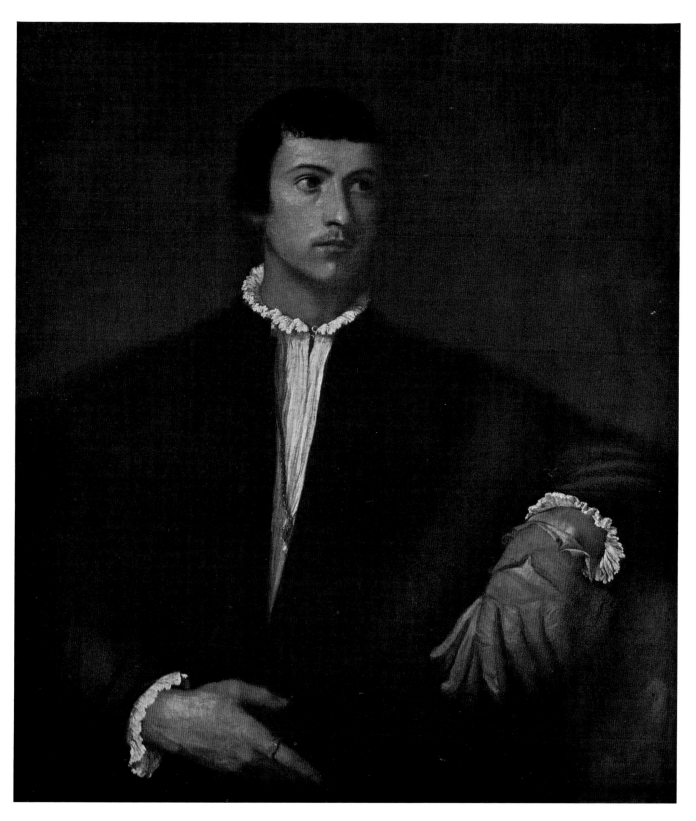

TITIAN (1477/87-1576). PORTRAIT OF A MAN WITH GLOVES, 1523-1524. (39¼×34¼″)
LOUVRE, PARIS.

open space and a diagonal line ascending towards her, emphasized by two tall pillars shooting up towards the sky. While there is no special beauty or religious feeling in the forms, this *Madonna* has a wonderful emotive power and we sense an aspiration towards an ideal which, though undefined, is fully achieved.

The famous *Venus of Urbino* (1538) in the Uffizi is altogether different. Despite the picture's title, this is the likeness not of a goddess but of a very human, enchantingly beautiful young woman waiting on her couch for the maid to bring her clothes. And it is not a pagan vision but a faithful portrait sublimated by its gorgeous colors.

TITIAN (1477/87-1576). PORTRAIT OF POPE PAUL III WITH HIS NEPHEWS ALESSANDRO AND OTTAVIO FARNESE (DETAIL), 1546. MUSEO NAZIONALE, NAPLES.

Titian was the inventor of a new style of portraiture, thanks to his objective, wholly unbiased vision of reality and his prodigious skill in creating harmonies of form and color. An excellent example of this is the anonymous *Man with Gloves* (Louvre), which not only "registers" to perfection a certain type of man but also has the immediacy of a likeness done from the life, a pictorial snapshot so to speak. Raphael's superb portrait of his friend Castiglione was also that of an individualized type figure but it had not this verisimilitude. Titian's peculiar gift was that of recording a moment of a life. Hence the unique forthrightness of his portraits, frank to a degree, yet invested with a noble dignity.

Brief mention may be made of some other portraits: *Andrea Gritti* in Vienna, remarkable for its dynamism and color; *Diego de Mendoza* in the Pitti Gallery, with its amazing color orchestration realized solely by effects of black on a dark grey ground; for here, by a strange alchemy of which he had the secret, Titian conjures up with these simple means colors that are, in the literal sense, "not there." No less magical is the way in which, while presenting figures full face and without real movement, he instills into them, by deft, almost imperceptible touches, the vibrancy of life. We see this in that wonderful portrait in the Pitti Gallery which has so often changed its name; once known as *The Englishman*, it next was called *Ippolito Riminaldi*, and finally, with better justification, *Ottavio Farnese*.

Paul III gave Titian the opportunity of making what is perhaps one of the most dramatic portraits known to art. The Pope is admonishing his "nephew" Ottavio in the presence of another "nephew," Alessandro Farnese. Ottavio is bending with feigned obsequiousness towards the man who is, in fact, his grandfather. The Pope's anger had been aroused by the news that the young man was intriguing against his father Pier Luigi, the Pope's son. The fiery indignation of the venerable pontiff, bowed and decrepit though he is, dominates the scene. The fact that the picture was left unfinished intensifies its emotive impact. Titian often painted dramatic scenes, but in no other did he reach this Shakespearian height of tragic power.

It must have been harder for him to break away from the tradition of official portraiture when his model was a prince or emperor. Yet it is these works that best reveal the independence he so jealously safeguarded in his dealings with the great ones of the earth and his feeling that his creative powers entitled him to rank beside them. An example is the *Portrait of Charles V with his Dog* (1532-1533) in the Prado. Without losing anything of the majesty befitting it, the Emperor's figure is humanized by the presence of the dog and the palpitating life that animates the picture. This is all the more remarkable when we remember that all Titian had to go on in this case was a portrait by the Austrian painter Jacob Seisenegger.

The bold originality of Titian's portraiture is even more conspicuous in the Munich *Charles V* of 1548. Though the background may have been added by some other hand, the general conception was assuredly Titian's—and it is superb. Charles is quite simply dressed, in black, like any ordinary citizen and like all the Venetians of the day, even the richest. Indeed this could be described as a Venetian, almost bourgeois portrait

TITIAN (1477/87-1576). THE EMPEROR CHARLES V AT THE BATTLE OF MÜHLBERG (DETAIL), 1548.
PRADO, MADRID.

study, were it not that the haughty expression of the face and a certain grimness in the gaze reveal the Emperor, conscious of his august prerogative. An even more famous portrait of the same year (Prado) shows him on horseback at the Battle of Mühlberg. The horse is black, the sky mottled with angry red; one might almost think the painter had a presentiment of the future when he made this picture—for, despite the rider's kingly mien, it might well be a celebration not of triumph but of death.

But Titian was too much a man of the Renaissance ever to repudiate the appeal of physical beauty. In the Prado *Adam and Eve* he celebrates the virile strength of Adam and the loveliness of Eve, weaving the movement of their arms and bodies into a graceful arabesque. Titian's rendering of their figures is quite different from Michelangelo's. Turning to account his studies of anatomy, Michelangelo took the bony structure of the bodies as his starting-point, then clad the framework of the skeleton with a softly undulating sheath of flesh and skin. Titian, however, viewed the model from outside, in its atmospheric environment, with the result that the beauty of the bodies he painted is never abstract or isolated, but that of living, breathing human beings.

TITIAN (1477/87-1576). VENUS WITH THE ORGAN-PLAYER, 1547-1548. (53 ½ × 86 ½")
PRADO, MADRID.

TITIAN (1477/87-1576). ACTAEON AND DIANA, 1559. (74¾ ×81½″)
COLLECTION OF THE EARL OF ELLESMERE, NATIONAL GALLERY OF SCOTLAND, EDINBURGH.

Titian painted many Venuses in his long career, but (as was perhaps to be expected)
those of his last period are the loveliest, an example being the famous Prado *Venus
with the Organ Player*. In the *Venus of Urbino* he had struck a realistic note, heightening
this effect by introducing servants into the scene. In later life he lifted the picture on

to another plane, that of a purely imaginary, not to say unreal, world. He depicted a nude woman reclining on a terrace overlooking a park, with a small dog and an organ-player beside her. Yet Titian's "best of impossible worlds" is not the fabric of a dream and it differs from Giorgione's in his "Concerts" by being far more objective.

In his portraits Titian made an end of those concessions to mannerist design in the Michelangelo manner which were the undoing of an earlier work, the Brescia *St Sebastian* (1522). But he was always haunted by notions of this order, for the good reason that none of his admirers ever dreamt of telling him that Florentine chiaroscuro and Michelangelesque line were alien to his genius; that his path lay elsewhere, towards a pictorial architecture in terms of light and color. In 1548 Paolo Pino voiced the eclectic theory of art then in vogue when he said that what an artist should aspire to was a combination of Michelangelo's form with Titian's color. Needless to say, Titian was quite aware that in his handling of form it was best to follow his own bent. Yet he could not always shake off Michelangelo's influence, especially in his nudes. This is why three pictures in the Salute, Venice, rate among his most conspicuous failures: *Cain and Abel*, the *Sacrifice of Isaac* and *David and Goliath* (1542-1544). But when in 1548-1549 he painted *Sisyphus* and *Tityus* (Prado), he completely integrated plastic form with light and shade; these works teem with cosmic energy and dramatic life, untrammelled by any would-be academicism.

After his return from Augsburg, Titian never left Venice again. He was now at the peak of his career and had little more to expect of life. He had created a style that harmonized exactly with the ideal of the aristocracy of his time, and he was adulated by the highest in the land. Though constantly short of money and often harassed by domestic worries, he was free to paint exactly as he liked, with the flattering assurance that each new picture would be greeted as a masterpiece. Yet even in his imaginative freedom there was a strain of sadness due perhaps to life-weariness but also to a too close acquaintance with the greatest men of the day. He had come to know that milieu, its pomps and vanities, all too well; the glamour had departed. Clear-sighted enough to see the calamities which involuntarily, driven by destiny, he had brought on Europe, the Emperor abdicated in 1556 and retired to a convent in Estremadura. Titian's escape from life was to engross himself still more deeply in his art and it was now, in his last years, that he took a bold forward stride towards a wholly new style of painting. Naturally enough Vasari, a Tuscan, was baffled by this startlingly "modernistic" art in which he saw only patches of color so disposed that the picture looked meaningless unless viewed from a considerable distance. Like many who came after him he could not conceive of forms devoid of contour lines and built up by light alone.

The mythological scenes might be described as poems inspired by Titian's cult of light and sensual relish of his medium, the gorgeous luxuriance of his palette. The *Danaë* (Prado), *Perseus and Andromeda* (Wallace Collection, London), the *Rape of Europa* (Gardner Museum, Boston), *Actaeon and Diana* (Edinburgh), the *Nymph and Shepherd* (Vienna) are examples of these pure poems of light and color, pervaded by the aerial vibrations which traverse the "mythologies" of his last period.

But he also had moods of profound depression whose influence makes itself felt in his *Crucifixions*, in the *St Sebastian* (Hermitage, Leningrad) and even in some religious pictures which in earlier days he would have treated with a bland serenity, such as the *Annunciation* (Venice, Church of San Salvatore) or the *Virgin and Child* (National Gallery, London), where a gentle play of light creates an atmosphere of tender, faintly nostalgic intimacy.

Some comparisons will indicate the change of style that took place in this, Titian's final phase. The Louvre *Entombment* (ca. 1525) is composed in terms of the movement needed to carry the dead Christ's body, and while the swiftness of the action heightens the dramatic effect, it gives the scene a purely external significance. The figures of Mary Magdalen and St John the Evangelist have much beauty, but the bodies in the foreground are over-modeled to the point of seeming ponderous. Though an admirable illustration of an incident, the scene lacks spiritual insight. Very different is the Prado *Entombment* (1559), where the composition is in depth, line is absorbed by color, detail subordinated to general effect. Modeled by gradations of light, the figures seem like weightless phantoms glimmering against the darkness of the background. This picture is not an illustration but a meditation on the Divine Tragedy, and is imbued with an intense emotion, absent in the Louvre *Entombment*.

No less revealing is the difference between the two versions of *Christ crowned with Thorns*, one in the Louvre, the other in Munich. The former was painted round about 1560, the latter some ten years later. In both alike light is the unifying principle. But in the Louvre picture the light strikes on solid bodies—Christ's limbs and arms for example —which cut it short abruptly. While there is no questioning the dramatic effectiveness of this procedure, it certainly tends to overstress action at the expense of the spiritual content. In the Munich picture, on the other hand, light roves freely through the composition, creating its own medium of expression, and is not cut short by any obstacle in the setting—thus the wall at the back and the bust of a Roman emperor included in the earlier work have been omitted. It is the light, and not the brutal conduct of the crowd, that creates the atmosphere of tragedy. For it is no normal illumination, though seemingly accounted for by the flaring lamps above, nor does it issue from them; this light is like an emanation of the malevolence of the mob surrounding Christ.

The *Martyrdom of St Lawrence* (Jesuit Church, Venice) marks perhaps the climactic point of Titian's researches in the domain of light. A dim penumbra, shot with broken gleams that flicker into life and die away abruptly, shrouds the scene in a mysterious gloom. Here we certainly have the point of departure for that "luminism" which, subordinating all things, even color, to the vagaries of light, was to be used to such magnificent effect by Rembrandt.

Titian pictured himself several times. In the Berlin *Self-Portrait* (ca. 1555) we see him full of dauntless energy, eager for new fields to conquer. Painted many years later, the side-face portrait in the Prado shows us a man worn out by the efforts of a long, crowded life, yet one within whom burns unquenched the sacred flame, source of that apotheosis of light which is the crowning glory of his art.

The vision of reality inaugurated by Giorgione and masterfully carried to its logical conclusion by Titian impressed contemporaries as a new, momentous discovery. Figures were no longer isolated but participated in the world around them, form was no longer linear but integrated into the texture of the picture, and the vibrancy of color made itself felt no less in full light than in semi-darkness. Needless to say, the Venetian painters were quick to explore the possibilities of this new art language that every artist could make use of individually, adapting it to his personal means of expression and thus taking another forward step on the path leading to the autonomy of art.

TITIAN (1477/87-1576). THE ENTOMBMENT, 1559. (54 × 68¾″)
PRADO, MADRID.

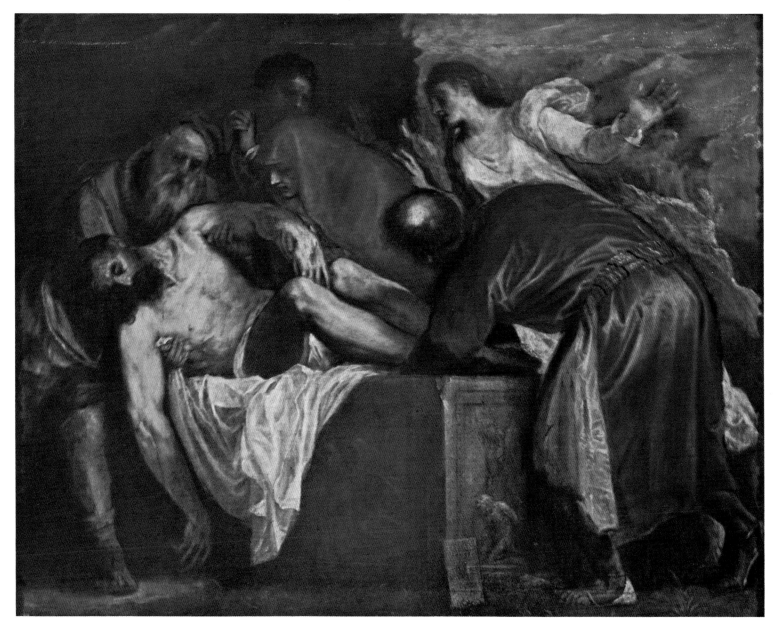

TITIAN (1477/87-1576). SELF-PORTRAIT, CA. 1555. (37¾ × 29½″)
KAISER FRIEDRICH MUSEUM, BERLIN.

TITIAN (1477/87-1576). CHRIST CROWNED WITH THORNS, CA. 1570. (110¼ × 71″)
ALTE PINAKOTHEK, MUNICH.

It was Sebastiano del Piombo who introduced this new way of seeing to the Roman art world, whilst Lotto made it known at Bergamo and in the Marches. And as was to be expected, Venice witnessed an influx of artists from provincial towns, amongst them Palma from Bergamo, Pordenone from Friuli, Dosso from Ferrara, Savoldo and Romanino from Brescia. True, at Brescia Moretto displayed a certain independence, as Moroni did at Bergamo. But, for that matter, all the artists named above made personal and significant contributions to Venetian painting as a whole.

Sebastiano Luciani, better known as Sebastiano del Piombo, was born in Venice about 1485; if Vasari is to be trusted, his death took place in 1547. Like Titian, he undertook the task of completing several pictures left unfinished by Giorgione—notably the *Three Philosophers*—and thus was one of the first artists to practise the "new style." After the master's death he moved to Rome where he did much to propagate the discoveries of the Venetian school. Indeed, though Lotto and Dosso also went to Rome, it was he above all who initiated Roman artists into the secrets of Venetian color and the new manner of painting. When we remember that Raphael was so much impressed by the innovations of the Venetians as to modify his style when he moved on from the *School of Athens* to the *Mass of Bolsena*, it is easy to understand Sebastiano's prompt success in Rome. But he in turn was influenced by what he saw in Rome, where Raphael and Michelangelo were adding to their laurels, and he set out to amplify Giorgione's achievement by infusing it with the Roman sense of plastic values. Gifted with an amazing power of assimilation, he went far towards combining beauty nearly as perfect as Raphael's with a monumental style little short of Michelangelo's. Having championed the cause of the latter in his rivalry with Raphael, he came to be regarded as the exponent *par excellence* of the Michelangelesque ideal. Except for a three years' stay in Venice (1526-1529) he spent the rest of his life in Rome. In 1531 he was appointed Custodian of the Papal Seals (hence his sobriquet "del Piombo") and in virtue of this post took the habit. Once he had become a monk, his activity as a painter diminished considerably.

The paintings made on the organ shutters of the church of San Giovanni Crisostomo show that when he was living in Venice he almost equaled Titian. In these paintings we see already certain characteristics differentiating him from Giorgione; a striving for monumentality, the fusion of light into color and (as Vasari noted) a tendency to accent relief. Given these characteristics, the course of his evolution once he was in Rome was a foregone conclusion. All the same his first work in that city, the paintings on the lunettes in the Villa Farnesina, was not a success. He employed the fresco technique and, though on the whole the colors blend harmoniously, the lay-out seems improvised and sketchy. But he quickly became acclimatized in Rome and, giving up elaborate compositions, devoted himself chiefly to portraits. Two, *La Fornarina* (Uffizi) and *Dorothea* (Berlin), show that, after a stay of little more than a year in Rome, he had already succeeded in combining the virtues of Raphael and those of Giorgione with the happiest results, in a style that was both delicate and forceful. The *Violin Player* of about 1515 (Rothschild Collection, Paris), in which the Raphaelesque element is more pronounced, is certainly one of the most attractive works of the Renaissance.

SEBASTIANO DEL PIOMBO (CA. 1485-1547). DOROTHEA, AFTER 1512. (30 × 23½″)
KAISER FRIEDRICH MUSEUM, BERLIN.

While Sebastiano del Piombo quickly mastered Raphael's elegance and plasticity, he had more trouble over Michelangelo's form and monumentalism. Nevertheless he succeeded in embodying these in the Viterbo *Pietà* (ca. 1517-1518). Here Christ's body forms the basis of a pyramid culminating in the Virgin's face, which thus acquires a monumental grandeur, as of an ageless effigy of grief, a grief that permeates the night-bound desolation of the landscape, one of the most tragic in all Italian art. There is no question that the figures were inspired by Michelangelo (even perhaps taken direct from one of his drawings) but the color is typically Venetian and moreover links up by effects of contrast the figures in the background. So it matters little that the structure of the human forms and the *contrapposto* in that of the Virgin derive from Michelangelo; though borrowing other painters' motifs, Sebastiano has achieved a wholly personal creation of the highest order.

Between 1517 and 1519, when he painted the *Raising of Lazarus* (London), a change came over his style. Its composition is frankly mannerist; the crowd of figures bears no relation—whether of harmony or contrast—to the background, and the color, while it retains the Venetian ripeness and juiciness, seems like a film applied to a pre-fabricated form. The same is true of the *Birth of the Virgin* (Santa Maria del Popolo, Rome), where the plastic values of the figures are too strongly marked for them to fit naturally into the perspective lay-out.

Best of the works of the painter's last period are his portraits: *Anton Francesco degli Albizzi* (Duveen Collection, New York), *Andrea Doria* (Galleria Doria Pamphili,

LORENZO LOTTO (CA. 1480-1556). THE CONDEMNATION OF ST LUCY, 1532. (12 ½ × 27 ⅛″)
PREDELLA SCENE OF THE SANTA LUCIA ALTARPIECE. PINACOTECA, JESI.

Rome), *Pope Clement VII* (Naples) and *A Cardinal* (Vienna)—imposing figures standing boldly out against the backgrounds thanks to a skillful use of chiaroscuro and color contrasts. Self-conscious virtuosity there certainly is, but also remarkable vitality; qualities that reveal at once this painter's strong points and his limitations.

Born in Venice about 1480, Lotto was a contemporary of Giorgione, Titian and LORENZO LOTTO Sebastiano del Piombo, but as an artist he stood outside the main currents of the age. In early youth he left Venice and found employment in various Italian towns where his works were fairly well received; not well enough, however, to prevent his dying a poor man, an inmate of the convent of Loreto. He was probably self-taught and while (like so many contemporary artists) borrowing much from other painters, he always struck a personal note in all he set his hand to. To start with, he looked to Giovanni Bellini, Alvise Vivarini, Dürer and Giorgione for guidance; then, in 1509, when he was commissioned to paint some rooms in the Vatican and moved to Rome, he came under the influence of Leonardo and Raphael—but not Michelangelo—and changed his manner, though without losing any of his originality. In the course of his long life he traveled widely, staying in 1495 (when he was a mere boy) at Recanati, then from 1503-1508 at Treviso. Following his Roman sojourn he lived at Bergamo from 1513 to 1526 and after a year in Venice he settled down at Jesi (near Ancona, in the Marches) where, apart from brief trips to Venice and Treviso and various towns in the Marches, he remained until his death in 1556.

LORENZO LOTTO (CA. 1480-1556). ST LUCY AT THE TOMB OF ST AGATHA, 1532. (12 ½ × 27 ⅛")
PREDELLA SCENE OF THE SANTA LUCIA ALTARPIECE. PINACOTECA, JESI.

LORENZO LOTTO (CA. 1480-1556). PORTRAIT OF A YOUNG MAN, CA. 1525. (18½ × 14¾″)
KAISER FRIEDRICH MUSEUM, BERLIN.

Unlike so many other painters of various degrees of eminence who left their home-towns in search of inspiration, fame and fortune at Venice, Lotto did not yield to the lure of the island city and its dazzling art; his interests lay elsewhere. Once in later life he reverted to the art tradition of his youth and fell under the spell of Titian, but the allegiance was short-lived. This unrest was not merely temperamental; it was, rather, an outcome of Lotto's innate piety. In him the religious sentiment took the form of a wholly personal, instinctive yearning towards God, and was very different from the official piety, sponsored by the Church, which was *de rigueur* in Venice during the first half of the Cinquecento and his pictures, imbued with the simple faith of the common people, found relatively little favor in the city of the Doges. Thus it was natural enough he should take over the religious motifs favored by Dürer, who certainly could not be accused of orthodoxy. "As good as goodness and as virtuous as virtue" (so Aretino described him), Lotto abstained from any polemic against tendencies he disapproved of, led a lonely life without family or pupils, launched no school, and was content with painting pictures after his own heart, many of them masterpieces. The first generation of mannerists, too, could be described as non-conformist. But whereas they stood for an intellectual approach, leading to abstract forms—a visual interpretation of the Platonic "idea"—Lotto kept very close to life, such was his devotion to natural forms and colors. Seldom pausing to take thought, he created with a fluent ease and fantasy rare in the history of art. He was more interested in details than in general effect and added wholly novel accents to a flower, a branch, light falling on a short flight of steps, a timid face, a look of contemplation, the gesture of the child St John stooping to stroke his lamb. So strong was his feeling for the natural world—a sort of Christian animism—that even in the light playing across foliage or weaving through the dark, even in stones and folds of garments, we seem to sense a soul within. Like Antonello, Lotto tends to give a cylindrical conformation to his figures, and often he recaptures the wistful grace of Bellini's Madonnas; but sometimes he blocks out the features of old men and even those of the Child Jesus with the extreme nervous acerbity that we instinctively associate with Dürer.

This failure to control his sensibility was at once a handicap and an asset to the artist. It enabled him to bring off some refreshingly spontaneous effects, unique of their kind and of their time, but it also prevented him from producing the large-scale works which were then the order of the day. Whereas by common consent one of the greatest achievements of the Renaissance was unity of vision, the integration of all the parts of a picture into a coherent whole, Lotto reverted to a lay-out that had obtained in the 14th century, and sometimes painted disconnected scenes on one and the same panel (at Trescore and Cingoli, for example). Though acceptable two centuries earlier, this method was bound to lead to confusion when the painter sought to reconcile two conflicting exigencies: that of a sequence of scenes on the one hand and, on the other, the principle of perspective and the subordination of all the elements to an over-all play of light. But sometimes Lotto turned this difficulty in his own manner by rendering details in so enchanting a way that one overlooks defects in the compositional scheme.

Starting out from the 15th-century Venetian tradition (still medieval in many ways) of the closed, precise and solid image, Lotto explored new and diverse fields of art, in each of which he scored brilliant successes, but he could not bring himself to keep to any single path. Revolutionary though it was, Giorgione's and Titian's art practice had been based on balance and good order. Lotto rejected these, followed the call of his creative fancy and took no account (or very little) of what his contemporaries were saying or doing.

The altarpiece he painted in 1505 for Santa Cristina al Tiverone, near Treviso, and the Recanati triptych of 1508 are typical of his first period. While inspired by Bellini, the composition is more dynamic. And the wonderful *St Jerome* in the Louvre (1506) proves that he was one of the finest landscape painters of the century.

His portraits form a class apart in his output; in them exceptional psychological insight is allied with much finesse of execution and a happy knack of handling form and color. Noteworthy, too, is the very human sympathy between the artist and his models; he not only observed their personalities but could enter into their feelings. In this context mention may be made of the three portraits of young men, in Vienna, Berlin and Venice, that of *Andrea Odoni* (Hampton Court) and above all the *Gentleman with Gloves* (Brera, Milan) in which it is not the outward man that commands attention but the revelation of the soul within.

On his return from Rome in 1514 Lotto painted an *Entombment* (Pinacoteca, Jesi); this must be written down a failure, since, in attempting to vie with Raphael, he lost sight of the need for building the composition into harmonious form. The same is true of the *Virgin and Child* in San Bartolomeo at Bergamo; in the predella, however, we see him at his best as a narrative painter and interpreter of sacred scenes on "modern" lines. Datable to the same period as the frescos in the Suardi Chapel at Trescore (1524) are several Madonnas and *Sacre Conversazioni* in which we see once again the warmth and tenderness of feeling which make Lotto one of the most endearing artists of his age. In a scene of the *Santa Lucia Altarpiece* (1532, Jesi) the animation and spontaneity are such that it might represent a quarrel among villagers in any Italian hamlet. At this time he was relying less on a variety of colors and painting chiefly in shades of grey, as is particularly noticeable in the predella. In the *Presentation in the Temple* (Palazzo Apostolico, Loreto) we have the culminating point of his spiritual and artistic evolution. There is something quite new to Renaissance art in the manner in which the scene is depicted— as no more than a gathering of some poor, humble folk in a vast, shadow-filled expanse; more than any contemporary Italian picture, it foreshadows the art of Rembrandt.

PALMA PORDENONE DOSSO DOSSI Propitious to experiments in style, the art climate of Venice enabled painters to develop their personalities to the full, and there were many who, while lacking the originality of such a man as Lotto, produced work of lasting value. Notable among these were Palma, Pordenone and Dosso Dossi.

Palma Vecchio ("the Elder") was born near Bergamo in 1480; he died in 1528. A highly expert technician, he was nothing of a dreamer. From Titian he acquired

his taste for painting attractive women in the flower of their youth and the true subject of the *Three Sisters* (Dresden) is the blonde beauty of his models, while his *Two Nymphs* (Frankfort) marks the climax of that unromantic sensualism which prevailed in Venice after Giorgione. In his religious works, such as the *Sacra Conversazione* (Academy, Venice), he succeeded in combining dignity with popular appeal. The Brunswick *Adam and Eve*, however, is one of his outstanding successes, forms being located in space with a firmness and solidity rare in Venetian painting of the period.

Giovanni Antonio de' Sacchis (1483/84-1539), commonly known as Pordenone, the name of his birthplace, after trying out various manners, elected to follow in the path of Giorgione. Then, in 1516, he went to Rome and henceforth showed more concern for plastic values, violent movement, and monumental effects. After working at Cremona and in Emilia he moved to Venice where in 1537 he was commissioned, in preference to Titian, to do some paintings in the Ducal Palace—not so much on his artistic merits as because, unlike Titian, he could be relied on to deliver the work at the due date. No less remarkable than his rapidity of execution was the boldness of his composition and a tendency to press his stylistic innovations to extremes; but we cannot help feeling he often gets his effects without much discernment or finesse and that his work has little real charm. Nevertheless his painting played an important part as one of the formative elements of Baroque.

Dosso Dossi, one of Titian's pupils, came of a family from Trento in northern Venetia. The first documentary reference to him is dated 1512—which places him in the group of Giorgione's immediate successors. In 1514 he was given a commission for work in the Este castello at Ferrara, and thereafter he was employed by that famous family for the greater part of his life. He died in 1542. His brother Battista, with whom he often collaborated, was a follower of Raphael rather than Titian, whereas Dosso, though occasionally borrowing from Raphael, rarely departed from the Titianesque manner. *Circe* (Galleria Borghese, Rome) is perhaps his finest work; color is stepped up to a flame-like intensity and form dissolves into it so thoroughly that the whole scene acquires an aura of mystery and magic. Hardly less striking are the *Nymph and Satyr* (Pitti, Florence), the *Court Jester* (Modena) and the *Holy Family* (Hampton Court), whose landscapes have a dreamlike charm. Unfortunately Dosso soon got into a rut, his inspiration flagged and his colors tended to lose their warmth and luster.

Gian Girolamo Savoldo was born about 1480 at Brescia, where as a young man he studied under Vincenzo Foppa. In 1508 he joined the painters' guild of Florence. He had a thorough grasp of both the new style sponsored by Leonardo and of traditional Flemish techniques with which he became acquainted chiefly through the work of Hugo van der Goes. There are good grounds for believing that he resided in Venice from 1521 to 1548, the year of his death. If the dating of his *St Anthony Abbot and St Paul the Hermit* (Venice) to 1510 can be relied on, it is clear that, after mastering Giorgione's and Titian's handling of light and shade, Savoldo had already developed a personal and highly accomplished style. In 1548 we find Paolo Pino, his pupil,

complaining that his teacher was not appreciated as he should be and indeed shamefully neglected; which suggests that Savoldo had much the same experience as Lotto. Still, unjust as this may seem, we must remember that in a city dominated as Venice was by the prestige of Titian and his associates, there was little chance for any other painter, however meritorious, to make his mark. In any case Savoldo, unlike Lotto, did not even try to align himself to Titian who, at the time when Pino made his protest, was at the height of his fame and worldly success. Moreover, whereas Lotto was a born experimentalist drawing inspiration from very diverse sources, Savoldo after some early ventures settled down into a style of his own from which he never departed. But it was an admirable style, and he did well to keep to it. Though we can sense behind it no mean intelligence, his form has a massiveness and simplicity that give his art a popular appeal; while his colored shadows reveal a fusion of Flemish tradition with the discoveries of Leonardo and Giorgione. But he handles form and color in his own way, stripping them of merely ornamental beauty in order to render appearances in terms of his personal vision. Modern critics have done well to stress Savoldo's contribution to the art of the future and the fact that if he cut an isolated figure it was because he was an artist ahead of his time and as such neglected by contemporaries.

It is in the light of these observations that we best can understand the modifications Savoldo brought to Giorgione's treatment of his subjects. He transformed the narrative picture into a genre piece so as the better to envelop landscape and figures in the dusk of evening or nocturnal darkness. His favorite themes were the Nativity, the Adoration of the Shepherds and the Rest during the Flight into Egypt. But he also painted isolated figures: a woman richly clad or half hidden under a flowing mantle, a shepherd, a flute-player, St Matthew visited by the angel. Whether he places his figures in a landscape setting or an interior, he always employs light of a special kind, limited in range and striking through a veil of shadows.

In the Crespi-Morbio *Nativity* and the various versions of the *Flight into Egypt* (Munich, Ragusa, Milan), certain details, such as the shepherd beside the fire in the first-named picture and the glimpses of the sea, mountains and ruins in the others, are, despite the precision given their forms, merely evocative recalls of the leading themes. In the *Magdalen* (National Gallery, London) Savoldo has transformed a very ordinary, not to say prosaic, scene—that of a woman wrapped in a big shawl walking by in the evening shadows—into a romantic vision, and in the *Flute-Player* (Contini-Bonacossi Collection, Florence) the relations between the room, the objects and the figures are stated with such ease and forthright realism that, despite touches of the elegance inseparable from Renaissance art, they anticipate the luminist procedures and crystal-clear precision of the 17th-century Dutch painters. For not a few independent-minded Venetian artists, looking beyond the Renaissance, prepared the way for some of the most valuable discoveries of the succeeding epoch.

Mention may be made of two other Brescian artists, Romanino and Moretto. Girolamo di Romano, called Romanino (1484/87-1566), seems to have had his early training in Venice in the milieu of Bellini and Giorgione whose influences are evident in

the *Deposition* of 1510 (Academy, Venice). When in 1513 he painted the large *Santa Giustina Altarpiece* (Padua), he displayed complete mastery of Giorgione's synthesis of form and color, though tending here and there to exaggerate the color factor. On the other hand the paintings made for the Duomo of Cremona in 1519-1520 show that he here was aiming at grandiose effects and elaborate composition, accompanied by some highly curious innovations in the handling of form.

Moretto (ca. 1498-1554), whose real name was Alessandro Bonvicino, was a little younger than Savoldo and Romanino. In his early phase he seems to have come under Foppa's influence, doubtless at second hand, by way of one of his pupils, since Foppa (who died in 1515 or 1516) could hardly have been his teacher. Next, he was drawn to Titian, but to Roman art as well, being particularly attracted by Raphael's form and Lotto's use of it in some of his pictures. Indeed it may be said that no other Lombard painter departed so widely as he from the orthodox Venetian tradition, this independence being due to his desire for an essentially formal beauty—hence his predilection for tender, silvery colors as being most suitable for harmonizing form with chiaroscuro. One of his happiest achievements is the Vienna *Santa Giustina*, which has a sedate grandeur all its own. While at first sight his art gives the impression of being more archaic than Romanino's, the unity and solidity of his color-form structure, far from being reactionary, pointed to the future. His *Feast in the House of Levi* (Santa Maria della Pietà, Venice), painted in 1544, anticipates the banquet-pictures which Veronese brought to such perfection. The altarpiece of *St Nicholas of Bari commending Two Children to the Madonna* (1539, Brescia) might be a scene of family life; indeed this gift for giving elevated subjects a homely flavor and a local setting is one of the charms of Moretto's art.

Giovanni Battista Moroni (1529/30-1578), a native of Bergamo, probably studied **MORONI** under Moretto, but he also drew inspiration, if with extreme caution, from Savoldo, Titian and Lotto. In his many religious pictures the execution is dull and lifeless; their one redeeming feature is a skillful use of color. It was with his portraits of notables of Bergamo that he made his name. All these people spring to life under his brush. He displays a rare insight into character and employs a technique that brings out the figures more effectively than would any detailed treatment, while silvery light seeping into the colors creates a subtle, all-pervasive radiance. Nothing of the artist's personal feelings about his sitters is allowed to intrude; hence the exceptional verisimilitude of his portraits. Best known is *The Tailor* (National Gallery, London), which doubtless owed its prompt success to the unusual nature of the subject; instead of painting a pope or emperor, or even a local celebrity, Moroni showed a tailor at work, scissors in hand. Thus portraiture, in which by definition the sitter's personality is all-important, was reduced to the condition of a genre scene. It is a noteworthy point that even the portraits on which he has inscribed the name of the model and the date, give the same impression of anonymity. Moroni's "truth," in short, is something more than factual or historical exactitude; it is of a purely artistic and, in the Aristotelian sense of the epithet, universal order.

It is impossible to evaluate the three great masters of the second half of the 16th century—Tintoretto, Bassano and Veronese—without taking into account the wave of mannerism that traversed Venetian art between 1540 and 1550. In the next chapter we shall attempt to define the nature of mannerism, but meanwhile we may prepare the way by isolating such of its elements as enter into the art of the three painters named above. Differing from other art historians, we do not think that any of them can properly be described as a mannerist; all three far overshot the confines of that movement, largely owing to the content of their pictures.

The motives which led Tintoretto, after some hesitation, to strike out in another direction, were of various kinds. A mannerist artist is, by his very nature, an intellectual; the making of a mannerist picture involves studious preparation, hard brainwork, painstaking research. Tintoretto was the opposite of an intellectual; he was a man of the people who happened to have a genius for painting, and when he took over some of Michelangelo's procedures, he gave no thought to the ideas that lay behind them. From Titian he may perhaps have learnt some methods of handling light, form and color, but always he adapted them to his own ebullient temperament, simplifying them to the point of changing them entirely.

At the time when throughout Italy the distinction between artist and artisan was becoming ever more pronounced, with the result that painters were growing class-conscious—Titian's elevation to the rank of Count Palatine was a symbol of their new prestige—Tintoretto still saw himself as an artisan, and took pride in being one. The fact, however, should be noted that the merit of the artisan consists in the pains he takes in giving finish to his work, and that Tintoretto's "slapdash" execution has become a byword. Aretino and Vasari were startled both by the headlong speed at which he worked and by his "almost infernal cleverness," but took him to task for his careless drawing. Yet this was Tintoretto's great discovery. After Michelangelo and Titian, painters needed to reacquire the craftsman's touch, that habit of leaving the maker's imprint on every stroke of the brush and substituting light for line so that the painting acquired the simple, natural aspect of the sketch. This may throw light on Tintoretto's conduct when at the San Rocco competition he submitted the finished picture instead of a cartoon. Leonardo's improvisations were limited to a few pencilled lines on paper; Tintoretto's took the form of gigantic canvases. Thus he made the decisive step towards the "unfinished" work of art which, ceasing to seem a mere preparatory sketch, exists in its own right and thanks to the uninhibited imagination that has gone to its making does not need to produce the effect of being completed. But the basic cause of Tintoretto's anti-mannerism was the religious sentiment which, evident chiefly in his later work, distinguishes him from all other artists of the day.

Titian had worked for a pope and two emperors and his pictures fall into two well-marked categories, sacred and profane. But Tintoretto worked for the Venetian Scuole Grandi of San Marco and San Rocco, institutions whose function it was to befriend the poor, and these confraternities took no notice of class differences. They accepted gifts of money from all and sundry and gave help to everyone who needed it. Being

very wealthy, they commissioned mural decorations and these dealt exclusively, as in the Middle Ages, with sacred subjects. Thus a religious scene by Tintoretto was like a pictorial "talk" addressed to the populace, intended to make known to them the underlying message of the biblical episodes represented, and to exalt their faith.

It would seem that in his youth Tintoretto had learnt much about the practice of art but that he lacked general culture. The driving force of his work derives, we feel, from his belief in God, the Virgin, the saints, the Christian legends and the mission of the Scuole—but still more from a profound faith in the value of what he was doing. He painted in a fine frenzy of creation, never standing back to appraise his work, and drawing on all the resources of an exceptionally fertile imagination. In this respect he outdid even Rubens, type figure of the artist who gives himself up, unreservedly, not to say exuberantly, to his creative impulse.

Tintoretto was a man of the people, worked for the people and shared their simple faith. At that time, when the Counter-Reformation was in full swing, when popes, emperors and Venetian ruling class were using religion as a means to shore up the temporal power, the masses took no interest in fine points of dogma, in Socino's theories or the problem of liberty of conscience. They left such matters to the intelligentsia, dutifully went to Mass, prayed, and yielded happily to the spell of the old legends that transported them so far from their drab, everyday lives. They were not so much ignorant as naïve, and the Bible stories appealed to them less for the lessons they inculcated

TINTORETTO (1518-1594). JOSEPH AND POTIPHAR'S WIFE, CA. 1544. (21¼×46″)
PRADO, MADRID.

than as poetry. No other artist felt so strongly as that true son of the people, Tintoretto, the ever-present actuality of the world beyond our ken or lived on such familiar terms with the people of the biblical stories.

This was obviously what might be called a primitive approach to religion and it is not surprising that Tintoretto has always been in high favor with admirers of the so-called Primitives. For he was not only a great narrative painter but also an inspired illustrator with the gift of imparting, as Ruskin pointed out, mysterious overtones to the most ordinary things, stones, leaves and shadows, and of opening windows on a super-real world.

The hugeness of his paintings is another striking feature of his œuvre. The conception of the Sublime may account for the relation between the notion of "great art" and the actual size of a work; in Tintoretto's case such are the dimensions of some of his pictures that they have the overwhelming power of a natural phenomenon when it assumes the aspect of a cataclysm. In this sense he is a man of the Renaissance; though he humanizes God and brings Him near to us, his universe is peopled with Titans and traversed by stresses of whirlwind force.

Jacopo Robusti, nicknamed Tintoretto because his father was a dyer (*tintore* in Italian), was born in 1518 at Venice, where he lived until his death in 1594. His life was uneventful, a long round of unremitting service to his art. Enrolled as a Master Painter in 1539, he soon assimilated not only the art of Titian but also that of Michelangelo and the foreign mannerists who had come to Venice. In 1545 he won the admiration of Aretino, but it was not till 1548 that his first triumph came with the *Miracle of St Mark*, painted for the Confraternity of St Mark. He entered into relations with the Scuola di San Rocco (Confraternity of St Roch) in 1549, and thereafter was employed by them until his death. In 1553 he received a commission for pictures for the Ducal Palace; in 1562 he dispatched a picture to the Gonzagas at Mantua, and in 1587 another to King Philip II of Spain. His last commission was to fresco a wall of the Council Chamber of the Venetian Senate, but he died before the work was actually begun. So far as we know, the only time he left Venice was when he made a trip to Mantua in 1580.

His contemporaries formed very different estimates of his art. Vasari said that his drawing was haphazard, improvised, and showed little discernment or mastery of design. Titian disapproved of him and, though one of his admirers, Aretino found fault with his "lack of finish." One of the Brothers of the Scuola di San Rocco offered to contribute fifteen ducats provided that any artist other than Tintoretto was employed for the decoration of the Sala dell'Albergo. When Tintoretto presented a painting as a gift in 1564, twenty-one out of fifty-one members of the Scuola were for declining it. Some time after this, however, the painter had his revenge, being made a member of the Brotherhood. In 1577 he was even allotted a fixed salary for life, on condition that he delivered a stated number of pictures per year.

Tintoretto's output was so vast and varied that only a partial account of it can be given here. First of his early works that calls for mention is a ceiling decoration made about 1544, now in the Prado. It consists of Old Testament scenes painted in

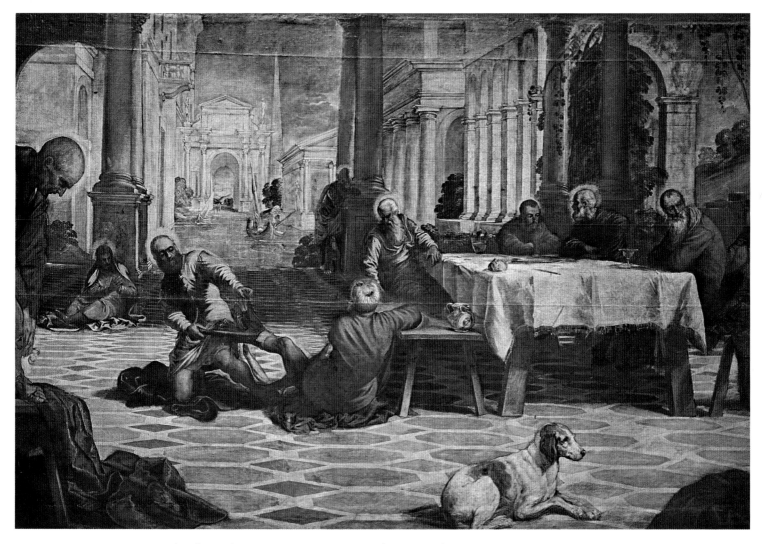

bright colors, flecked here and there with a sort of dewy efflorescence. Bodies are elongated in mannerist fashion and gestures form graceful arabesques, creating a decorative rhythm rather than any sense of dramatic action. One of the best scenes is *Joseph and Potiphar's Wife*, where the woman's nude body is saturated with light and emphasis is laid on empty space rendered in illusionist perspective so as to stress, by contrast, the figures and their movement.

Very different in conception is the *Washing of Feet* (Prado), which is built up by oppositions of light and shade that, together with the general lay-out, create a sense of drama all the more instant because in this picture Tintoretto ceased to trouble about decorative effect. The dramatic element here is essentially pictorial, that is to say independent of the subject; it stems wholly from the artist's unfettered imagination. There is a tonal relationship between the light hues of the background and the penumbra of the foreground, telling out dark upon light, in which glittering touches form glancing

aureoles around the bodies. These are so arranged as to allow of empty spaces giving the composition a rhythm neither linear nor plastic, but composed of sudden apparitions, the figures seeming like so many flashes of light. Any massing of the personages or the use of perspective would have hampered that free play of the imagination to which this picture owes its intriguing power.

On its appearance (in 1548) Tintoretto's *Miracle of St Mark* (now in the Academy, Venice) was hailed as a masterpiece, though there were some who qualified their admiration. Its merits are so conspicuous that we can easily understand its prompt

TINTORETTO (1518-1594). THE MIRACLE OF ST MARK (ST MARK DELIVERING A SLAVE), 1548.
(13 FT. 7 IN. × 17 FT. 9 IN.) GALLERIE DELL'ACCADEMIA, VENICE.

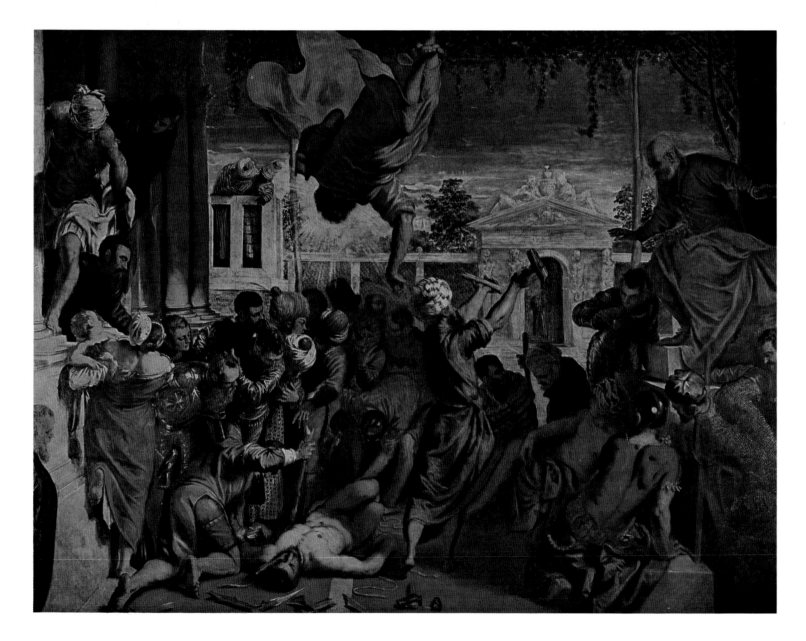

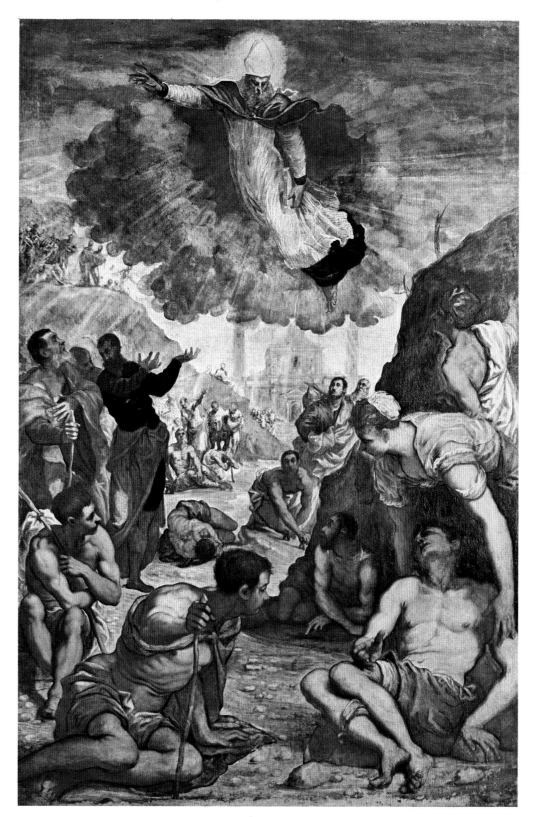

TINTORETTO (1518-1594). ST AUGUSTINE HEALING THE LEPERS, 1549-1550. (100½ × 67")
MUSEO CIVICO, VICENZA.

success and even today there could be no better point of departure for an appraisal of Tintoretto's art. Pallucchini has rightly observed that this picture was not due to a sudden flash of inspiration, but the outcome of long years of study and research. It has something grandiose about it that is absent in the earlier works, and reveals a greater harmony between the style and the essentially dramatic theme. But in adapting the style to such a theme there was always the risk of lapsing into rhetorical effect and we are conscious of the struggle it must have cost the artist to bring his task to a successful conclusion. Working in this manner, he had no time for reflection; he boldly identified movement with action, and the presence of the crowd ruled out those empty spaces which had set the rhythm of, for example, the *Washing of Feet.*

But after bringing off this triumph, Tintoretto could afford to let his imagination run free, and in *St Augustine healing the Lepers* (Vicenza) he achieved a *contrapposto* between the groups and the open spaces, between tracts of light and pools of darkness, that creates a world of magical enchantment. *Adam and Eve* (now in the Academy, Venice), one of his best works, belongs to the cycle of Old Testament scenes made for the Scuola della Trinità and dates probably to the middle of the century. Here "subject" is reduced to a minimum: two bodies rendered with an extreme textural richness, vibrant with inner life; and it is the landscape—nature idealized—that plays the leading part in creating the poetic atmosphere of the scene.

From 1564 to 1588 Tintoretto was employed almost continuously on the decorations of the Scuola di San Rocco.

The *Crucifixion* (1565) covers forty feet of wall; the size made it possible to represent a great throng of people, while allowing for empty spaces and imparting to the groups a movement extending to the far horizon. All compositional elements are caught up in a vast gyration centering on the sublime image of the Cross; nothing is static, earth and sky seem to participate in the divine tragedy. By a special handling of light even the open spaces are made to contribute to the general effect; they are given an organic life of their own and act as sources of a weird illumination that strikes through the darkness falling from a lowering sky. In *Christ before Pilate* the entire composition is dominated by the pale form of the Savior. Tintoretto has not sought to personalize the emotions of either of the leading figures, but to convey the atmosphere of the tragic scene, the purity and truth symbolized by the tranquil, white-stoled figure, while those whose eyes are blind to that purity and truth are relegated to the shadows. In *Moses striking Water from the Rock* no stress is laid on the miraculous aspect of the event, the water gushing forth is the leading motif, paralleled by the swirling movement of the crowd of onlookers. The *Adam and Eve* in the Scuola di San Rocco, datable to 1577-1578, is quite different from the picture in the Academy of Venice on the same theme made twenty-five years earlier. Tintoretto's joy in painting bodies bathed in light is of the past; the atmosphere of the scene deprives it of any sensual appeal and brings home to us only the momentous significance of the Fall. The setting of the *Adoration of the Shepherds* is a hut, divided into two stories so as to isolate the Nativity proper from the scene below and to differentiate the divine from the human elements.

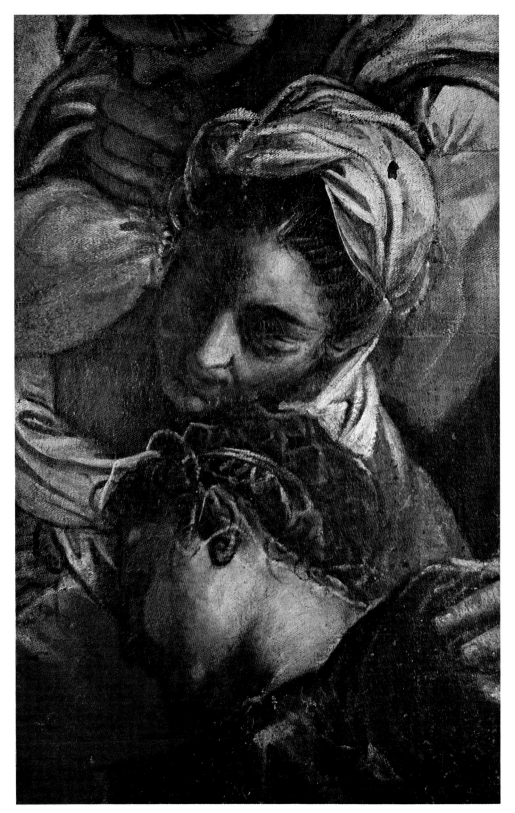

TINTORETTO (1518-1594). THE CRUCIFIXION, DETAIL: THE TWO MARYS, 1565.
SCUOLA DI SAN ROCCO, VENICE.

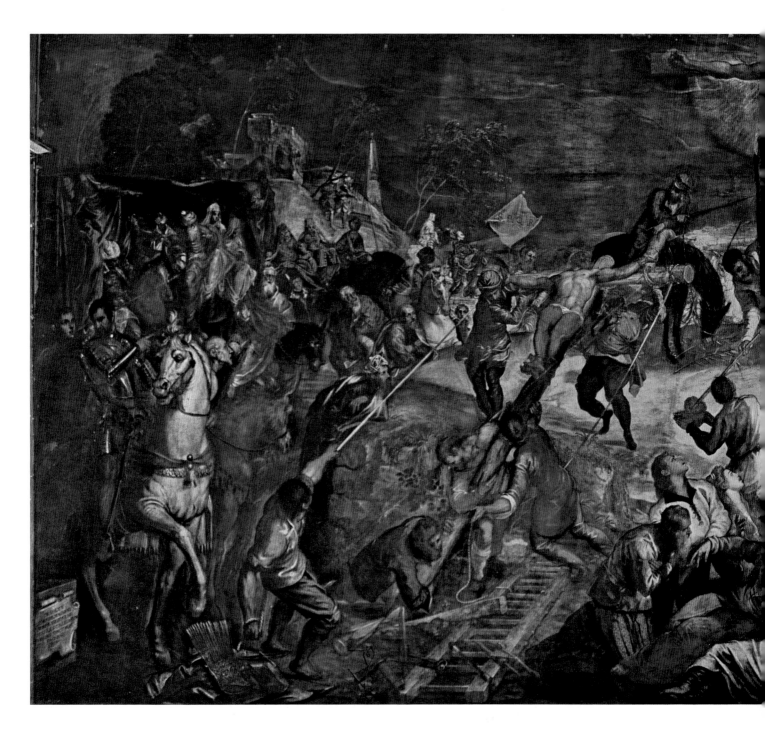

TINTORETTO (1518-1594). THE CRUCIFIXION, 15

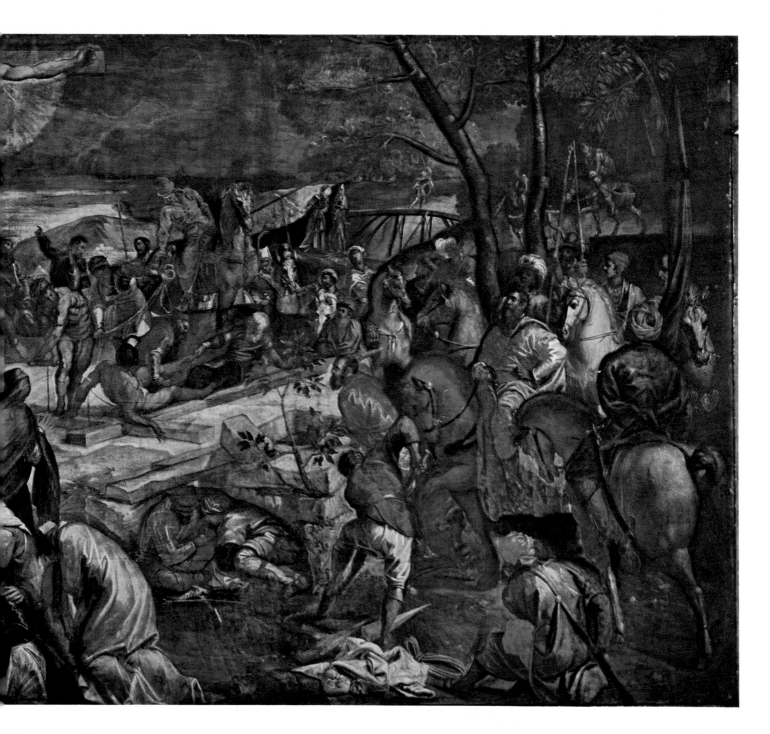

½ FT. × 40 FT.) SCUOLA DI SAN ROCCO, VENICE.

TINTORETTO (1518-1594). THE CRUCIFIXION, DETAIL: ST JOHN THE BAPTIST, 1565.
SCUOLA DI SAN ROCCO, VENICE.

Some luminous touches bring out the awe-struck look on the faces of the participants. In the *Baptism of Christ* the distant crowd beyond the half-light of the foreground and middle distance where the action is taking place is plunged in sunlight so vivid as to make it look like a fantastic trelliswork of quivering filaments of light.

In the *Last Supper,* owing to the composition in depth, Christ is placed at the near end of the table. The apostles form an agitated group, appalled by the Master's terrible announcement. Eighty years had passed since Leonardo painted his fresco in Santa Maria delle Grazie, Milan. In Tintoretto's rendering of the scene nothing remains of the spirit of the Renaissance; of its architectural composition, its plastic values, its stress on individual character. Such a tempest of emotion surges through this scene that there could be no question of individualizing expressions. In the dim light the apostles form a somber mass, dramatically lit by a few rare gleams. The Renaissance is over, mannerism left behind; Tintoretto's handling of light in this *Last Supper* is unequivocally Baroque.

But in the *Ascension* we find another mood. The dancing lights and shadows breathe rapturous joy, and flails of light edging the angels' wings seem to be bearing the Savior heavenwards.

In 1582-1583 Tintoretto painted two quite different pictures: the *Annunciation* and the *Massacre of the Innocents*. In the former Gabriel, swooping down through an opening in the wall, cuts a rather material figure and the picture seems a mere bravura piece, devoid of any transcendental intimations. On the other hand, in the *Massacre of the Innocents*, greatly admired by Ruskin, Tintoretto refrained from depicting isolated acts of brutality, agonized expressions, streaming wounds and the livid hues of death; he transmuted the human tragedy into a catastrophe on the cosmic level, its horror rendered solely by effects of light and shade.

The *Flight into Egypt* belongs to the same period. On the left is the slow procession on donkey-back and on the right one of the loveliest landscapes ever painted, owing its beauty less to the actual scenery than to an exquisitely balanced play of light. About a year later came *St Mary of Egypt* and the *Magdalen*; the setting in each case is a vast, enchanted landscape and here again it is light that quickens our sense of mystery, peoples the solitude and imbues wild nature with friendly life. Last of Tintoretto's San Rocco paintings was the *Visitation* (1588) in which, after so many scenes of crowded life, he returned to the reposeful composition, with few figures, of his youth. All the *Visitation* shows us is two women, simple, humble forms in front of a deep spatial recession—the painter's farewell, touching in its modesty, to the gigantic picture cycle he had worked on for over twenty years.

In the course of his long life Tintoretto lavished peerless treasures, pictures charged with that sublime magic of which he had the secret, on various Venetian churches and confraternities. The Scuola di San Marco, which had provided him with the opportunity of scoring his first success with the *Miracle of St Mark*, gave him a commission, in 1562, for three more pictures. In the *Removal of St Mark's Body* (Academy, Venice) and the *Finding of St Mark's Body* (Brera, Milan), the rendering of space dominates the theme.

And it is to light yet again that these scenes owe their dramatic power; the light flooding a vast public square in the first picture and, in the second, striking on a row of tombs. In the *Adoration of the Golden Calf* (Madonna dell'Orto, Venice) the incantatory power of the picture and its dramatic effect stem from the clouds encircling the mountain top where Moses is being given the Tables of the Law.

Although constantly employed on large-scale works, Tintoretto found time to paint many portraits, in which the figures, dashed off in feverish haste, spring to vivid life against dark backgrounds with the instantaneity of lightning flashes. The very rapidity of the effect obtained individualizes the personage represented. Unlike Titian and Lotto, he did not aim at bringing out the inner life of his models—but surely it is a mistake to regard the "psychological portrait" as the *nec plus ultra*; as Baudelaire observed, the portrait may be history and it may be art. Tintoretto's imagination was too fertile and too active for him to content himself with "history." He intended his images to make an immediate, convincing impression on the beholder, and in this he succeeded. Examples are the unforgettable *Portrait of a Man* (1553, Vienna), the *Young Nobleman with a Golden Chain* (Prado), *Vincenzo Zeno* (Pitti), *Jacopo Sansovino* (Uffizi), *Alvise Cornaro* (Pitti), *Doge Pietro Loredano* (National Gallery, Melbourne) and *Nicolò Priuli* (Frick Collection, New York).

In his justly famous *Susanna and the Elders* (Vienna) we feel that the artist has only just shaken off the influence of mannerism. The nude body is even more brilliantly illuminated than the one in *Joseph and Potiphar's Wife,* and this light builds up a form that is more solid and in stronger contrast with its surroundings than any of Titian's figures. All the rest—glimmering background, hedge of rose bushes, trinkets, fallen garments and so forth—serves merely to bring into prominence the woman's body emerging in lonely splendor. This picture is exceptional in Tintoretto's œuvre; in it he has concentrated his attention on light rather than on color, which here performs an essentially formal role. Though the subject is biblical, it is transposed into a frankly pagan key, thanks to the airy lightness of the brushwork. In some of his "mythologies," such as *Mercury and the Graces* and *Ariadne, Bacchus and Venus* (ca. 1578, Ducal Palace, Venice), Tintoretto seems to have drawn inspiration from the elegantly spontaneous rhythm of the Vienna *Susanna*. Reminiscences of it can also be traced in his strangely fascinating *Deliverance of Arsinoë* (Dresden), where the nudes, the hero in full armor, the ship, the sea, the distant light and nearby shadows conjure up before us a poet's vision of a romantic dreamland.

Tintoretto's inventions and discoveries defy enumeration. In the *Crucifixion* (1568) in San Cassiano, Venice, the crosses are foreshortened so as to heighten the effect of the storm that is breaking overhead and the lances fretting the horizon. In the Berlin *Annunciation* the figures act as guide-marks leading the eye towards a central burst of light. And it is light on sea and sky that gives its dramatic instancy to the miracle in the *Vocation of St Peter* (National Gallery, Washington). In the Louvre *Paradise* the movement set up by the many-colored masses of figures disposed, circle within circle, around the vast effulgence of the sky gives the scene an overwhelming emotive

power, though individual figures are hardly distinguishable. The same theme is treated, on a colossal scale, in the famous canvas in the Ducal Palace (1586-1590), which proved, if proof were needed, that at the age of seventy Tintoretto was far from having exhausted the resources of his copious imagination.

Between 1591 and 1594, that is to say in the last three years of his life, he painted, for San Giorgio Maggiore, a *Last Supper*. The general effect is even more eye-filling

TINTORETTO (1518-1594). ARIADNE, BACCHUS AND VENUS, CA. 1578. (57½ × 61¾″)
DUCAL PALACE, VENICE.

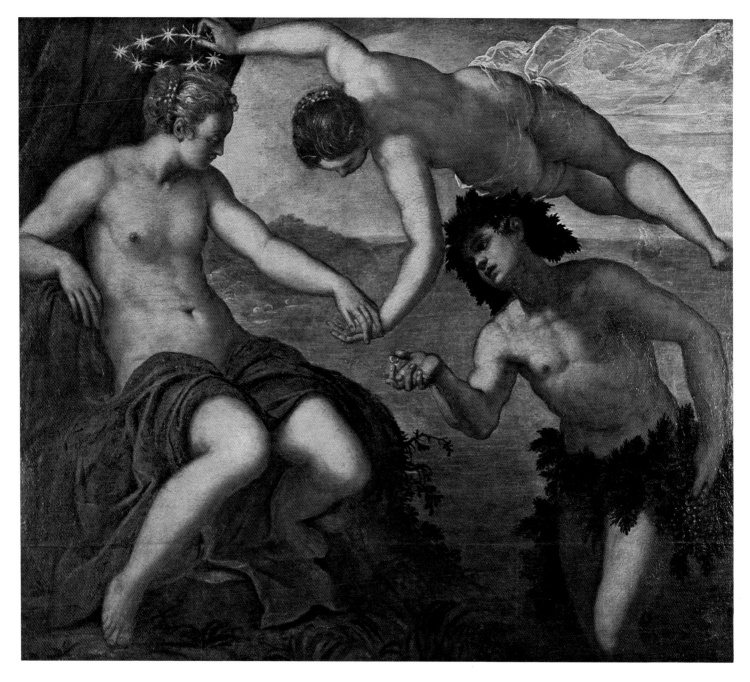

than that of any of the earlier works, so dazzling are the sudden bursts of light, so dramatically bold the rendering of infinite space. This is, in fact, an early example of the exuberant vision of Baroque.

On a general survey of Tintoretto's œuvre, what strikes one most perhaps is the incantatory quality of his art; almost we feel that he is deliberately trying to cast a spell on the beholder. Then, looking deeper, we perceive the profound religious feeling that led him to present biblical and saintly personages, even God himself, under an aspect that was human and intelligible, yet conveyed intimations of transcendence, of the godhead immanent in all things. Light and shadow, space and movement are his means of expression and a masterly use of one of the richest palettes known to painting makes them live before us. Characteristic of his art are its warm humanity, its combination of popular appeal with a sense of the otherworldly, the mystery and magic he imparted to the facts of visual experience. Abandoning Titian's style and leaving mannerism behind, he blazed a trail towards the "luminism" of the next century.

TINTORETTO (1518-1594). THE LAST SUPPER, 1591-1594. (12 FT. × 18 FT. 7 IN.)
CHURCH OF SAN GIORGIO MAGGIORE, VENICE.

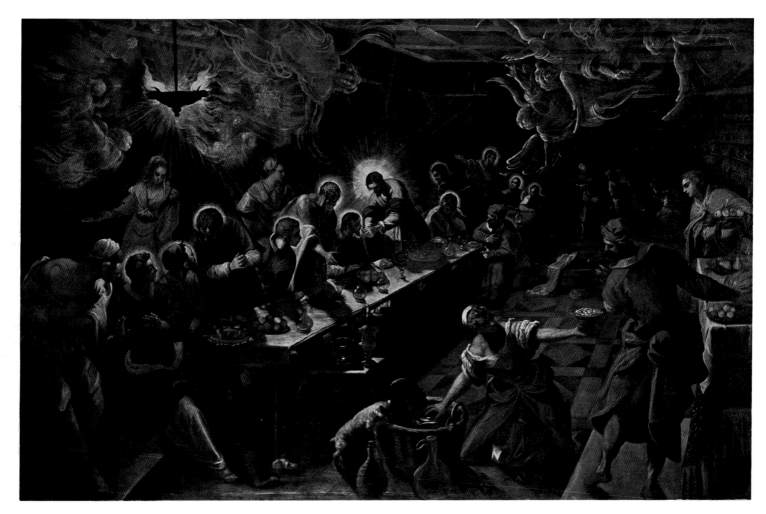

JACOPO BASSANO (1510/15-1592). THE ADORATION OF THE SHEPHERDS, 1568. (94½ × 59¼″)
MUSEO CIVICO, BASSANO.

JACOPO BASSANO Another great Venetian painter was Jacopo da Ponte, called "Il Bassano," who devoted himself to representing the life of peasants and shepherds, using as its setting the countryside around the small market-town of Bassano, in Venetia, from which he got his name. Before this, however, he had drawn on various sources of inspiration and it was only after much experimentation that he realized he could give freest play to his imagination and highly personal style in scenes of country life. One of his characteristics was a feeling for the intrinsic beauty of color, which led him to break up the outlines of forms in order to adapt them to this new conception of color and give it full effect. And this special sensitivity enabled him to put the physical properties of his medium to the service of spiritual values in works that amply justify the high esteem in which contemporaries held them.

Writing in the 17th century, Marco Boschini said that Bassano's brushstrokes and touches of color were "like so many gems: rubies, emeralds, turquoises and diamonds that sparkle even in darkness." But what appeals to us today is not merely the iridescent sheen of his colors but also his gift for instilling their very texture with a vibrant life no previous painter had achieved and which indeed remains unequaled.

Though living in a small, out-of-the-way town, Bassano enjoyed immense success, and this he owed not only to his exquisite colors but also to his novel interpretation of religious themes. Pictures of legendary figures divinely beautiful but rendered with a rhetorical, hollow magniloquence were beginning to pall. So it is easy to understand why Bassano's presentation of the biblical stories in terms of everyday peasant life and with complete sincerity was so readily welcomed; it must have come as a relief after the high-flown showpieces of the late Venetian School.

It is perhaps a little saddening that Masaccio's and Alberti's visions of man as an heroic figure, center of the universe, should have dwindled, less than two centuries later, into amiable scenes of pastoral life and peasants' kitchens cluttered with pots and pans. But the course of art history is paved with such regrets, and there could be no turning the clock back. The Renaissance, one of the most brilliant eras of European culture, had had its day and we see here the humble beginnings of that long, slow evolution which was to lead up to the flowering of 19th- and 20th-century art.

Born at Bassano some time between 1510 and 1515, Jacopo da Ponte produced his first work in 1531 when still a pupil of Bonifazio dei Pitati. His five years' training under that master (1530-1535) enabled him to shake off the provincialism inculcated by his father Francesco da Ponte the Elder. When the latter died, he became head of the family and received official recognition from the municipal authorities of his hometown. His talent ripened slowly; in a picture made in 1540, the *Supper at Emmaus* (Cittadella), his interpretation of the face of Christ is uncouth to the point of ugliness, though he was more successful in making a convincing figure of the innkeeper. This was in fact an early token of his true vocation. Moreover, in a slightly previous work, the *Flight into Egypt* (Bassano), datable about 1537, he had, it seems, already realized the necessity of striking a realistic note. But, once he had outgrown Bonifazio's influence, he turned towards the Italian and foreign mannerists then in vogue in Venice,

assimilating their methods with remarkable skill. Evidently he hoped to acquire from others the qualities he lacked: beauty, elegance, and also a certain sleight of hand.

But what he still needed was to effect a fusion between his innate naturalism and the mannerist procedures he had espoused so wholeheartedly; to break his line so that color could make play with the intervals; and to learn that through the medium of color he could give entire expression to his creative impulse. Subsequently to 1562, the year in which he painted in his new style the *Crucifixion* for the church of San Teonisto at Treviso, he produced a series of masterpieces, amongst them *Pentecost*, the *Manger*, the *Baptism of St Lucilla, Podestà Sante Moro commending a Donor to the Virgin, St John the Baptist* (all in the museum at Bassano), *Jacob's Journey* (Hampton Court), *St Peter and St Paul* (Modena), *St Jerome* (Venice), *Adam and Eve* (Pitti). While differing in composition, all have in common a treatment of space enabling the artist to present figures in depth and to submerge mannerist elements with his glorious color.

His health broke down in 1581 and thereafter, until his death in 1592, he produced little work of his own. His four sons, Francesco, Giambattista, Leandro and Girolamo took over his themes and exploited them with much success.

Titian, Tintoretto and Bassano had made haste to discard mannerism, after it had **PAOLO VERONESE** served their turn, and to integrate their linear and plastic form into the new vision of reality as color, light and shade. After 1550 all three tended to restrict their range of colors and to stress the role of light; this "luminism," a tendency to see the world in terms of light and dark, was premonitory of the spiritual malaise of the 17th century.

But Paolo Veronese, last of the great Venetian painters of the Renaissance, felt no such qualms; in his art all is *joie de vivre*, serenity and certitude, frank enjoyment of the contemporary scene. For though born in Verona, Paolo was the most brilliant interpreter of the aristocratic, luxurious life of Venice in her Golden Age. Like other great painters of the time, he set much store on color, but used it in a very different way. Once he had discovered its exact relationship to light, he gave each hue its utmost brilliance, with the result that shadows dwindle into a vague penumbra, often hardly perceptible, and the color sings. Other artists, Tintoretto in particular, had taken the obvious course and employed dark shadings so as to throw light into relief; Veronese succeeded in making his light tell out on a bright ground. The painter's black is always darker than any black in nature, and his white far less luminous than natural light. But if even the darkest tone is kept relatively pale, it is possible, by bringing it into relation with the brightest tone, to produce an effect of intense luminosity, approximating to the light of day. This is one of the reasons why Veronese, after being little understood in the 17th century, was so much appreciated and imitated in the 18th, when *peinture claire* came into vogue again.

Paolo Caliari, commonly called Veronese, was born at Verona in 1528. At the age of thirteen he began studying under Antonio Badile, and he remained in his hometown until 1553. After he had thoroughly mastered his art, he settled (in 1555) in Venice where, except for a few brief journeys, he resided until his death in 1588.

In 1560 Francesco Sansovino wrote: "Paolo is beginning to make a name for himself both as an excellent painter and also as an agreeable talker, a young man pleasant to consort with." Looking at his pictures, we can see why this was so. Tradition has it that even Titian, hard to please as he was, liked Veronese. And the instant appeal of his paintings, coupled with his personal charm, was rewarded by a career of unruffled success, a happy marriage and many children, a trip to Rome, close friendship with the great architects Palladio, Sansovino and Scamozzi, and lucrative assignments.

Newly arrived from a provincial home, the young artist was dazzled by the colorful life of Venice at her apogee, the round of brilliant festivals, the beauty of the costumes of both men and women, the spacious palaces and loggias, and the elegance of the Venetian nobility. Tintoretto had always remained a man of the people; the outlook on life of Veronese, a stone-breaker's son, was that of an aristocrat born to the purple—as indeed is evident in all his work.

When the Inquisition arraigned him in 1573 for having introduced into his *Feast in the House of Levi* such incongruous figures as dwarfs, people dressed like Germans (i.e. protestants) and buffoons, he retorted that painters, like poets and madmen, were entitled to take liberties and that anyhow, in this picture, his commission was "to ornament it as seemed good to him." But the worldly pomp and splendor of his compositions, notably his great banquet-pictures, and the lack of feeling in his renderings of Christ show that, with some rare exceptions,

PAOLO VERONESE (1528-1588). ST MENNAS, AFTER 1560. (97 ¼ × 48″) GALLERIA ESTENSE, MODENA.

the alleged religious theme counted for relatively little in his painting. His last big work was the *Triumph of Venice,* and we might almost say that, whatever the ostensible subjects of its predecessors, Venice had always been their source of inspiration.

In expressing his untrammelled joy in the splendors of Venetian life and in building up his gorgeous color-orchestrations governed by a rhythm that never falters but gathers strength continually no matter how great the picture surface to be covered, Veronese deliberately dispensed with several of the elements made use of by other painters, such as overt movement. True, he is capable of making his figures move in space and renders perspective with skill, but it is "pose" that determines the movement of the figures and their balanced distribution within the limits of the picture. For though he has no difficulty in producing effects of depth and spatial recession, he prefers to spread out the images upon the surface, and in a good many of his works places a crowd of figures in the extreme foreground against a backdrop of buildings and open sky.

PAOLO VERONESE (1528-1588). YOUTH BETWEEN VICE AND VIRTUE, CA. 1570. (40⅛ ×60⅛″)
PRADO, MADRID.

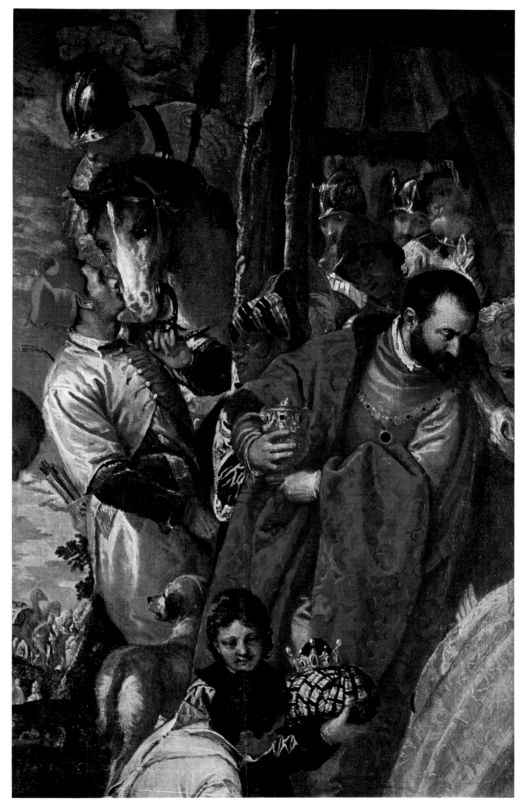

PAOLO VERONESE (1528-1588). THE ADORATION OF THE MAGI (DETAIL), 1573.
CHURCH OF SANTA CORONA, VICENZA.

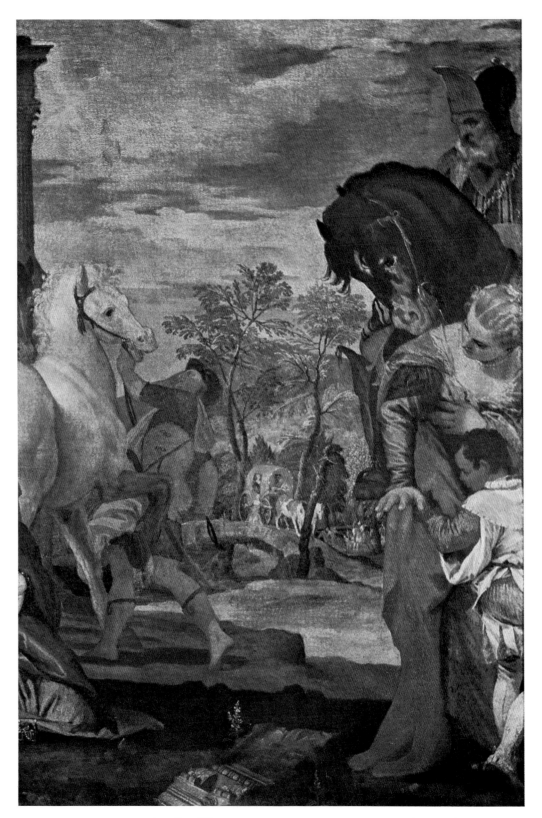

PAOLO VERONESE (1528-1588). THE MARTYRDOM OF ST JUSTINA (DETAIL), 1575.
MUSEO CIVICO, PADUA.

Other exceptional qualities of his art are its smiling grace, emotional detachment and a serenity that in his day seemed somewhat out of date. This has recently led some to affiliate his work to the classical art of the High Renaissance. But though Veronese is as serene as Raphael and this fine tranquillity is a quality of the very greatest art, his style, far from being classical, is more in line with our modern sensibility than with that of the Renaissance during the first half of the 16th century. The art of Veronese is not a throwback but, more perhaps than that of any of his contemporaries, points the way to the future. Therein lies his strength. The serenity of his art is the outcome of a gift for absorbing the most diverse elements and uniting them in a coherent whole bearing the imprint of his style. There is nothing of the artisan in his make-up; nowhere in classical art do we find that consciously patrician air which makes its first appearance with Veronese and was to characterize the new aristocratic art of the Baroque period.

In his early efforts we see how many and how varied were the sources he drew on. The Bevilacqua-Lazise altarpiece (1548, Verona) shows the influence of Antonio Badile, his teacher; the decoration of the Villa Soranza (1551, Castelfranco) that of Giulio Romano's mannerism; and the *Transfiguration* (1555-1556) in the cathedral of Montagnana (like all the works of this period) reveals the combined influences of Raphael and Titian.

But by 1555-1556, when he painted the frescos in the sacristy of San Sebastiano, Venice, Veronese was in full possession of his style. Notable in the *Crowning of Esther* is his success in solving the problems of formal structure; the scene is viewed from below, the play of light brings out the density of masses, while colors acquire a deep-toned resonance against the luminosity of the sky. Esther is one of the first truly beautiful women he painted and the magnificence of the setting is worthy of her beauty.

Given his temperament, it was natural that Veronese took every opportunity of painting scenes of feasts and banquets, and these in fact are his most famous works. Since in them he had not to use the "frog's-eye view" needful in ceiling decorations, he could give vivacity to these pictures without detriment to the harmonious distribution of the figures, and thus achieve a satisfying balance between the vitality basic to movement and the tranquillity appropriate to contemplation. These feast scenes also gave him opportunities of filling the background with architectural features, in which his friendship with leading architects led him to take a special interest. Though on the face of it mere accessories, these architectural elements, thanks to a double play of light, have an important part in the color-scheme. A glowing flood of light sweeps over the images in the foreground; then becomes paler, more attenuated, as it glances across the architecture in the distance, investing it with a remote, dreamlike glamour.

Most effective of these banquet-pictures are the *Feast in the House of Simon* (ca. 1560, Turin), the *Marriage at Cana* (ca. 1562-1563, Louvre, and 1571, Dresden), the *Feast of St Gregory* (1572, Monte Berico, Vicenza) and the *Feast in the House of Levi* (1573, Venice). In the last-named picture, above all, the rhythmic arrangement of figures and architecture, their alternate presentation in depth and on the surface, the delicate sheen of the background, the balanced disposition of colors across the luminous

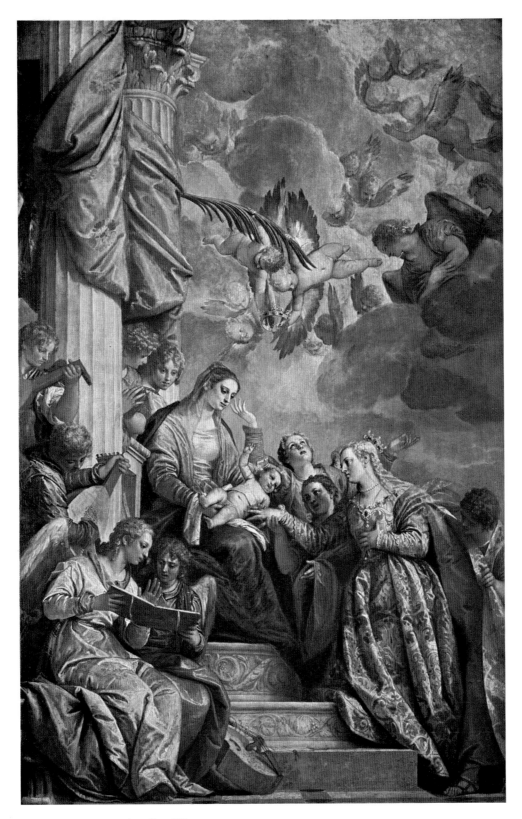

PAOLO VERONESE (1528-1588). THE MYSTICAL MARRIAGE OF ST CATHERINE, CA. 1575.
(12 FT. 4 IN. × 8 FT.) GALLERIE DELL'ACCADEMIA, VENICE.

expanse have an effect on the beholder that is well-nigh overwhelming. Though the themes are religious, there is no religious emotion in these pictures and it is noteworthy that the figure of Christ is the one that, as usual, Veronese renders least successfully. Since he was called on to paint "feasts" he thought fit to depict those he had seen with his own eyes, the spectacular banquets that were then a feature of Venetian life. But the fascination he found in these scenes led him to picture them under an ideal aspect and to invest them with a compelling grandeur unique in this genre.

Veronese liked painting surfaces of vast dimensions whose width much exceeded their height (as in these "feasts") and which permitted him to present his subject on the surface against a luminous ground. Some of the most striking of the pictures in which he used this format are the *Family of Darius before Alexander* (National Gallery, London), the *Adoration of the Magi* (Dresden), and the *Madonna with the Cuccina Family* (ca. 1571, Dresden).

With Palladio as architect and Veronese as painter the luxurious Villa Giacomelli built at Maser (near Treviso) by the Barbaro family became the "finest pleasure-house of the Renaissance." The landscapes on the walls seem like so many windows open on the countryside and harmonize perfectly with the figures beside the doors, on the balconies and ceiling. But Veronese did not aim at any illusionist realism; there is an airiness and vivacity in these scenes that make them seem like glimpses of some lovely, lost Arcadia. Most remarkable of his decorations is that in the Audience Chamber of the Ducal Palace, painted between 1575 and 1577. In *Venice attended by Justice and Peace* and the figures of "Virtues"—*Meekness* and *Simplicity* especially—we see visions of feminine beauty which, for glorious color and delicate handling of shadows and volumes, have never been surpassed by any other artist.

Towards the end, Veronese lost something of his serene detachment. Conscious of the tragic side of the age he lived in, he gave expression to his new sense of compassion and fellow-feeling for suffering humanity in Pietàs and Crucifixions. Also in some works of this period, for example his *St Helen* (National Gallery, London), where the saint robed in white believes she sees angels carrying the Cross, he strikes a visionary note; but such works are adventitious, half unwitting revelations of his belated change of heart. For his true vocation was to hymn the glories of Venice, her pomp and pageantry. More than any other artist it was Veronese who created the legend of Venice in the sunset glow of her splendor and opulence, before the hard times came—a legend whose glamour will endure, whatever changes time may bring.

MANNERISM

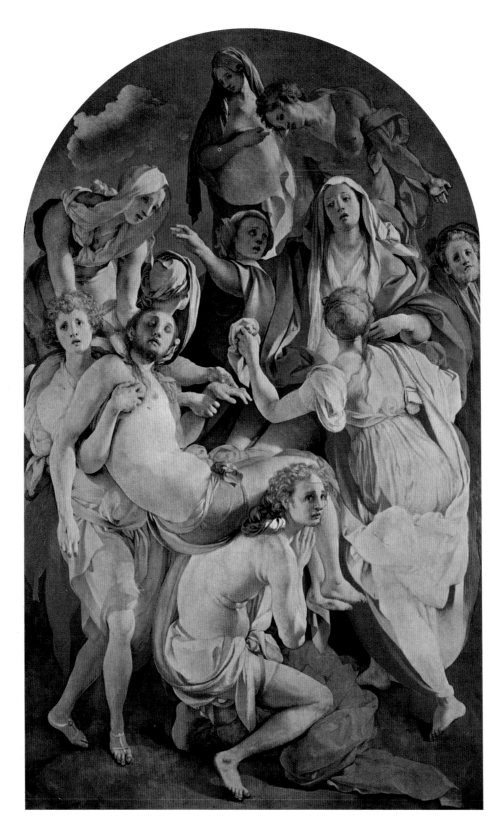

JACOPO PONTORMO (1494-1556/57). THE DEPOSITION, 1525-1528. (123 × 75 ½″)
CAPPONI CHAPEL, CHURCH OF SANTA FELICITA, FLORENCE.

3

FROM PONTORMO TO EL GRECO

FROM about 1515, when Pontormo, Rosso and Beccafumi came on the scene, until 1614, the year El Greco died, the art style known as "mannerism" was in the ascendant. During the 17th century it fell into disrepute and until quite recently the term "mannerist" always conveyed disparagement—an injustice which modern critics, very rightly, refuse to countenance. Vasari when he used the word *maniera* was merely thinking of an artist's personal style; for Bellori, however, it implied "mannered," or "resulting solely from the artist's 'fantasy,' not from imitation (of nature)." And thereafter, until the end of the 19th century, this absence of the element of nature-imitation was the reason why mannerism was frowned on. But today when so much stress is laid on the creative imagination, the fantasy so brilliantly present in the work of mannerist painters has no lack of admirers.

However, before turning to study the art of some typical mannerist painters regarding whose merits there can be no doubt, we must try to find an answer to the question: "What exactly is meant by 'mannerism'?" Actually it is as hard to define as the epithets Baroque and Gothic. These movements were too vast, too complex, to be resumed in any cut-and-dried definition; the most that can be done is to describe their salient characteristics and to set forth the ideas on art prevailing amongst the painters who took part in them.

Since it is usual to describe the art of Raphael, Fra Bartolomeo and Michelangelo (in his early phase) as classical, we may say that one of the distinctive features of mannerism is its anti-classicism. Whereas the three artists just named were admired for the balance they struck between the ideal and the real, the mannerists sacrificed the representation of reality to an ideal of elegance, refinement and delicate perfection quite other than the Raphaelesque conception of the beautiful. Since naturalness was the least of their concerns, they may be described as "formalists"—but in no pejorative sense; their interest in form was so intense that its realization became in effect the content of their art. Moreover they practised an illusionist realism peculiar to themselves, of a kind we are tempted to describe as "surrealistic."

This cult of form gave rise to a conception that has had much importance in the history of art: the conception that art is not the imitation of nature but a product of the mind and a creation of the "inner eye." Leonardo, too, regarded painting as an intellectual activity. But to his thinking the function of the intellect was to elicit and

interpret the secrets of nature; the mannerists, on the other hand, regarded the operation of the mind, begetter of forms that have only an indirect relation to nature, as an end in itself. In short, the artist was enjoined to create without spontaneity, without *laisser-aller* or concessions to popular or religious sentiment; his work was to be subjective through and through. But art cannot operate *in vacuo*, and for their raw material, so to speak, the mannerists turned to the great masters, Raphael and Michelangelo, and not to nature. Thus their contacts with nature were at second hand. So great was their aversion from imitation that, when they could not succeed in creating, they felt compelled to "invent." This invention exercised itself chiefly in their figures and motifs, and with these they crowded their compositions; for they had little relish for depicting space since this would have forced them to give their figures a more natural expression. So studied an art was bound to be intellectual. Even in their happiest moments, when by charming flights of fancy these painters succeed in making us forget their intellectual bias, this is not due to any instinctive sensuality but to that calculated action on the senses known as erotism. Thus the gulf between them and the great Venetians is apparent. When Titian achieved his new vision of reality there was no question of divided purposes or any intellectual problems to be solved, and his discovery of color values owed as much to his senses as to his mind.

Given their refinement, the mannerists tended to shut their eyes to "base reality," and as was to be expected they had most success in the courts of Francis I and Henry II, then the most elegant in Europe. On the other hand, however, we must not forget that, owing to its development over a long period and in different places, mannerism had to adapt itself to a great diversity of local conditions. To begin with it reflected the discontent of certain Tuscan artists who could neither accept classical form and its immobility, nor ecclesiastical art, then no less stagnant as compared with the new modes of religious expression discovered in Germany and made known to the Italians chiefly through Dürer's engravings. But this first wave of revolt soon came to a halt, inhibited by court etiquette and the exigencies of the social order of the day. Of this the Counter-Reformation was quick to take advantage; until the end of the century it imposed on mannerist art appropriate disciplines, more concerned with decorum than with moral considerations. Soon, however, it became clear to the ecclesiastical authorities that mannerism was not acceptable enough to the populace at large to play the propagandist part they asked of it and accordingly they turned towards the Baroque, then in its early phase, an art form that exactly met their requirements.

During the second half of the Cinquecento, in fact, the mannerists lost ground; they had kept too close to the forms of Michelangelo and Raphael, rule-of-thumb had replaced invention. It was they who founded the first academies, at Florence in 1563 and in Rome in 1578, which, though doubtless helpful to the artists personally—since they raised their social standing—did nothing for art itself. And it was in Spain that Renaissance mysticism found its true pictorial expression; El Greco's visionary genius and his impassioned inward drive realized to perfection the mannerist ideal; no other artist had conjured up so compellingly a world transcending visual experience.

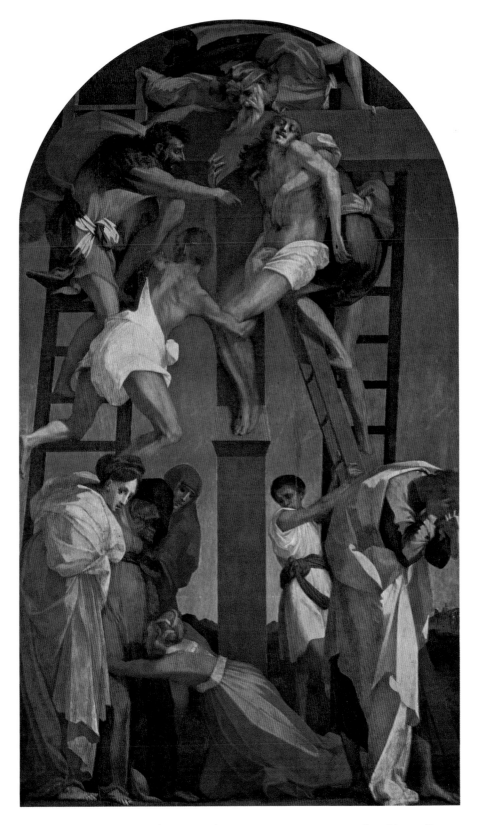

ROSSO FIORENTINO (1495-1540). THE DEPOSITION, 1521. (147¼ × 77″)
PINACOTECA, VOLTERRA.

This brief account of the type forms of mannerism will explain, we hope, our reason for not speaking of mannerist tendencies in the case of such men as Brueghel, Bassano and Tintoretto who, by and large, saw the world through the eyes of the ordinary man and were in no sense "intellectuals." Whatever paths they followed, their art belonged to a world in which no possible distinction could be drawn between style and reality, between the thinking mind and the creative imagination.

PONTORMO AND THE TUSCAN MANNERISTS

Jacopo Carrucci, called Pontormo after the town where he was born in 1494, launched the mannerist movement in Tuscany. When, after studying under Leonardo, Piero di Cosimo, Mariotto Albertinelli and Andrea del Sarto, he set up as an independent painter in 1513 or 1514, he had prompt success. The Medici family commissioned him to make the decorations in their country house at Poggio a Cajano. In 1530 Michelangelo sent him some cartoons to use as models for paintings. After the return of the Medici to Florence he continued working for them and in 1546 was given an assignment to fresco the choir in the church of San Lorenzo, on which task he was engaged until his death in 1556/57. This work (now destroyed) was universally condemned by those who saw it as a hopeless failure.

In the *Sacra Conversazione* (San Michele Visdomini, Florence), painted in 1518 in his early youth, all the characteristic features of Pontormo's style are already present. There is no attempt to render space, figures are assembled in such a way as to come flush with the picture surface, "representation" gives place to "presentation." But these figures have no beauty in themselves, they are badly proportioned and twisted into preposterous attitudes so as to convey a sense of emotion wrought up to fever pitch. Yet it was with this work that a young artist aged twenty-four, dissatisfied with the moral and intellectual climate of the day, gave a new direction to Renaissance painting. In 1518 it was no longer possible to feel the simple religious faith of the Middle Ages, and in any case the Platonic Idealism then in vogue precluded direct relations with nature and any such intimate association between mind and matter as was attained by Titian—who in this same year was painting his *Assumption* for the Frari church. In his *Commentary on Plato's Symposium* Marsilio Ficino, stressing the incompatibility of mind and nature, declared that beauty was a revelation of the secret consonance of all things with an ideal order, and of a spiritual rather than a corporeal nature, a proportion of parts, not beautiful *per se*, within a perfect whole. Spiritual values, in short, had to be isolated from sensations and the mind debarred from placing any reliance on nature. Another of Ficino's dicta was that "we must forget what we have learnt because in learning it we renounced the study of ourselves." By dint of heroic efforts Michelangelo succeeded in overcoming this antagonism between mind and nature. Pontormo was a different type of man; no fighter but sensitive and high-strung, he preferred to retire from the struggle and give himself up to his soul-searchings. He invites the spectator to fill out in his imagination the hints, allusions and curious implications present in his works; hence their undoubted charm, a charm that is, however, a total negation of the rationalism practised by the humanists.

The *Supper at Emmaus* (1525, Uffizi) and the *Visitation* (ca. 1530, Carmignano) are typical of Pontormo's art; there is no action, the motionless figures look like disembodied spirits. He does not strive for any dramatic effect; on the contrary, settings and atmosphere are those of some fabled land of dreams, giving the impression that Pontormo knew his incapacity for treating such subjects on the plane of actuality. Between 1522 and 1525 or thereabouts he frescoed scenes from the Life of Christ in the Carthusian monastery of Galluzzo, employing motifs culled from Dürer's prints. Vasari—and probably most of Pontormo's contemporaries—resented this; the idea of discarding the "Italian manner" and drawing inspiration from a relatively little known artist of the far North struck them as ill-advised, to say the least of it. But today we can easily see why Pontormo was drawn to Dürer; he found in him a fidelity to reality that had ceased to exist in Florentine art, and moreover a religious and moral earnestness now confined to those who were in sympathy with the Reformation, whether inside Italy or abroad. Thus the Galluzzo frescos have a distinctive quality of their own, absent in the general run of Florentine painting. In *Christ before Pilate* the figures are rigid, open spaces emphasize the tragic isolation of Christ, his anguished suspense and the sublime significance of the event. But these frescos are in too poor a condition for us to form an opinion of their original color. The *Deposition* in Santa Felicita, Florence, has stood up much better against the ravages of time. Despite the theme the colors are bright and pure, devoid of chiaroscuro, at once delicate and brilliant as jewels touched by sunlight. A restless movement animates the figures, its purpose being solely to implement the sensuous rhythm of a tantalizingly intricate arabesque.

Pontormo's portraits are usually complete successes; in these the very nature of the subject forced him to take notice of the facts of visual experience. But there can be no doubt that he pointed the way to mannerism by the clean-cut distinction he drew between the Idea and the physical world, between mind and matter, an antithesis he felt so acutely that in the end his mind became unhinged—yet it is precisely this spiritual unrest that gives his art its very real greatness.

Giovanni Battista di Jacopo di Gasparre, commonly known as Rosso Fiorentino, was born at Florence in 1495. After entering the painters' guild in 1517 he was given a commission to fresco the *Assumption* in Santa Annunziata, Florence. In 1521 he painted the Volterra *Deposition* and in 1525 *Jethro's Daughters* (Uffizi). In that year he moved to Rome where he lived until 1527, becoming a close friend of Michelangelo. The sack of Rome compelled him to leave that city and he visited several Italian towns —Perugia, Borgo San Sepolcro, Città di Castello, Arezzo—before setting out for France in 1530. Given the appointment of court painter to the king, he decorated, in collaboration with Primaticcio, the Pavilion of Pomona (1532-1535); also, between 1534 and 1537, the Galerie François I at Fontainebleau. He made many designs for costumes, silverware and "Triumphs," notably one in celebration of the visit of the Emperor Charles V. He died in France in 1540.

Rosso's art, like that of many other painters of the day, shows the joint influences of Leonardo, Fra Bartolomeo, Michelangelo and the Germans, Dürer in particular.

Thus it bears the mark of that cultured sophistication which characterizes Florentine painting after the first decade of the Cinquecento. All the same, his style is more original than that of Pontormo, with whom he was closely associated at one time. His work has none of the complexity and feverish tension that give Pontormo's art its curious appeal, but his forms have greater actuality and he brings off some striking effects of color. Yet, while endowed with more facility and fluency than that highly temperamental artist Pontormo, he remains always on a slightly lower level.

In the *Deposition* the monochrome background is painted a dark blue—not the blue of the sky—against which the other colors stand out violently, keyed up to their maximum intensity. Stressed by forms built up in facets and by extravagant gestures, they acquire the shrillness of a cry of despair, but a despair that, lacking co-ordination, is all on the surface. Another outstanding feature of this picture is the strongly centrifugal impulse given the lines of force governing the composition. Here the painter has replaced both the monumental conceptions of Renaissance art and the expression of Christian sentiment by a fantasia of forms, products of a brilliantly fertile, often willfully bizarre imagination, and interpreted the subject on boldly symbolic lines. Symbolism is even more conspicuous in *Jethro's Daughters*. Two prostrate figures are being struck by a third, while a young girl stands aloof in an attitude of studied indifference suggesting she is the cause of the affray. Space is non-existent, so crowded is the scene with bodies telling out strongly against the background, though the contrast between lights and darks is due more to the colors than to any attempt at modeling. *Jethro's Daughters* and the *Deposition* show Rosso at his best. Had he stayed in Italy, he would certainly have worked in isolation; as it was, by going to France he became the founder of the School of Fontainebleau. For his work on the Galerie François I he had many French and Italian helpers. The technique of this decoration in which painting and stucco ornamentation are combined to happy effect was quite original, though it may have been suggested by a decoration carried out by Raphael and his assistants in Rome. Notwithstanding the fact that this work has suffered much from the injuries of time and rough handling, the unity of lines, colors and volumes, despite a rich variety of motives, is such that it ranks high as an example of a large-scale decorative ensemble governed by free fancy, yet executed with consummate artistry.

Domenico Beccafumi was born near Montaperti, probably in 1486; after receiving his early training at Siena he went to Rome to perfect his style by a close study of the works of Raphael and Michelangelo. Returning to Siena in 1512, he came under the influence of Sodoma, whom he sought to outdo on his own ground. After this he worked at Pisa and Genoa. He was also a sculptor and executed a marble pavement in *commesso* work for the cathedral of Siena. He died in 1551.

His sensitive handling of light and his *sfumato* implemented by a dexterous use of lights and darks qualify him to rank as a mannerist. His *Communion of St Catherine* (Siena) is imbued with poetic emotion, and an exquisite sensibility makes itself felt in the handling of light and shade in his *Nativity* (San Martino, Siena). It is clear that to begin with he shaped his style on Leonardo; then, when in Rome, he turned

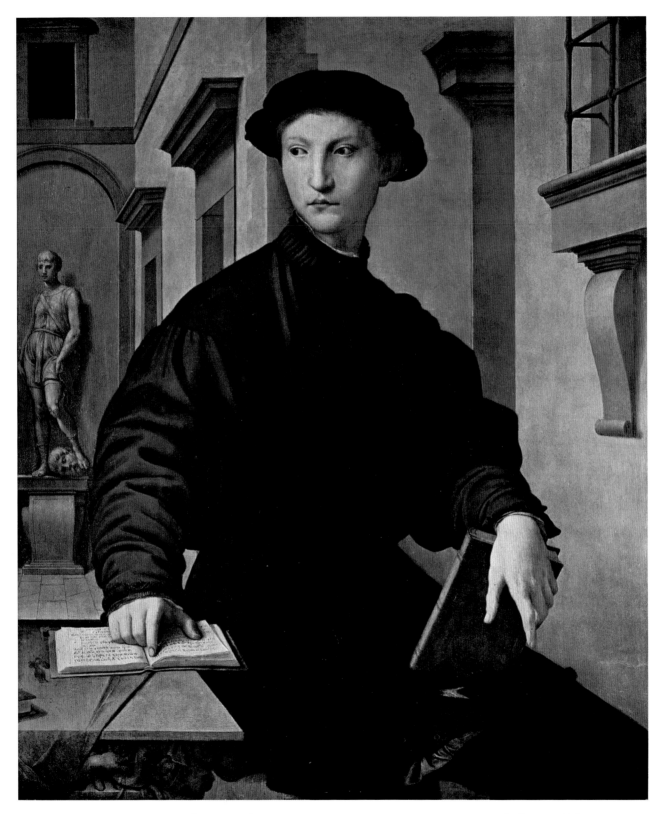

AGNOLO BRONZINO (1503-1572). PORTRAIT OF UGOLINO MARTELLI, 1537-1538. (40 × 33 ½″)
KAISER FRIEDRICH MUSEUM, BERLIN.

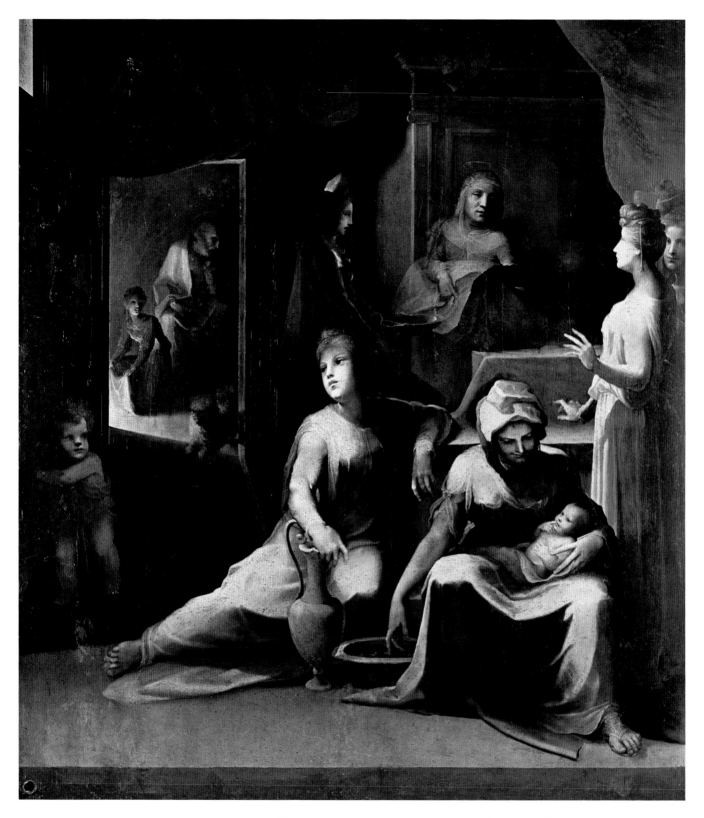

DOMENICO BECCAFUMI (CA. 1486-1551). THE BIRTH OF THE VIRGIN (FRAGMENT), 1543.
PINACOTECA, SIENA.

towards Raphael, and at Siena towards Sodoma and other painters. But better than any of his contemporaries he saw how Leonardo's *sfumato* could be carried a stage further, and it was this in fact that led him to the discovery of "luminism." Thus he is entitled to a leading place among the Central Italian painters of the first half of the century.

Born at Florence in 1503, Agnolo di Cosimo, better known as Bronzino, brought to its extreme conclusion the Florentine mannerists' cult of abstract forms. He died in 1572. Pupil and assistant of Pontormo, and much influenced by Michelangelo, he became court painter to Duke Cosimo de' Medici and inaugurated that series of portraits of members of the Medici House on which all 16th-century court portraits were modeled. In the early *Portrait of Ugolino Martelli* (1537-1538, Berlin) he already employed his characteristic lay-out of dark, contrasting forms against a bright background, an arrangement that ran counter to the practice of the day. We find in his handling of form a sense of tension and solidity that enables him to combine successfully geometrical abstraction and concrete reality. However, when in 1545-1546 he painted the famous *Portrait of Eleonora de Toledo and her Son* (Uffizi) he relaxed the tension with the result that here the form seems over-abstract and essentially decorative. Noteworthy in this portrait is the painter's new, aristocratic vision, leading him to treat the subject almost like a sacred effigy standing on an altar. In the allegorical picture of *Venus, Cupid, Folly and Time* (National Gallery, London) form is solidified to the point of absurdity; not only the faces but bodies, too, seem mask-like, unnatural. In fact when he had not the living model to impose a salutary restraint, as in the portraits, Bronzino tended to let his imagination get out of hand.

Like the Florentines, a Parma artist Francesco Mazzola (1503-1540), known as Parmigianino (i.e. the little Parmesan), tended to the use of abstract forms, but, less doctrinaire in his abstractionism than such men as Rosso and Pontormo, he achieved a fragile grace and delicacy, reminiscent both of Raphael and Correggio. His universal popularity contributed largely to the spread of mannerism in Europe.

MANNERISM IN NORTH ITALY

The *Madonna of the Long Neck* (Uffizi, Florence) illustrates to perfection his aesthetic. Here elegance replaces beauty and the somewhat abstract treatment of the figure gives it an immaterial charm. His *sfumato*, his discreet allusions to reality, the elongation of proportions and the sinuous movement of his figures were enthusiastically followed up by many painters in the second half of the Cinquecento.

Primaticcio (1504-1570) might be described as Parmigianino's most accomplished disciple, though he never actually studied under him and was closely associated with Giulio Romano and his group at Mantua. After being employed for six years by Duke Federigo Gonzaga, he was sent by his patron, in 1532, to the court of the French king. He quickly won the favor of Francis I, was appointed court painter, and worked on the Fontainebleau decorations. Architect and sculptor as well as painter, he lacked perhaps the high originality and forcefulness of Rosso but his work has more spontaneity and a refined distinction all its own and he played an important part in the founding of the School of Fontainebleau.

Niccolò dell'Abbate, born at Modena in 1509 or thereabouts, was Primaticcio's collaborator at Fontainebleau, where he died in 1571. Influenced by Dosso Dossi and later by the Flemings, he took over their imaginary landscapes but re-interpreted them in a quite original manner. In Niccolò's art we find a graceful sinuosity of line, a tendency to elongate figures and a subtle handling of *sfumato*. Thus he was well qualified to accompany Primaticcio to France (1552), where he consolidated his reputation, already well established when he left Italy. This was largely owing to his landscapes, which he ingeniously diversified with genre scenes—a procedure that provided mannerism with one of its most fruitful fields of action.

That remarkable *Landscape with Men threshing Wheat* (ca. 1555-1560) at Fontainebleau is now attributed to him. The composition is frankly anti-classical, the stack of straw being quite out of scale with the rest of the scene; still it makes a fine patch of color. In the figures, too, we find a satisfying blend of realism and stylization.

The œuvre of Lelio Orsi of Novellara (1511-1587) shows how comprehensive was the artistic culture of the day even in a small provincial town. For it reveals a host of diverse influences: those of Giulio Romano, Correggio, Parmigianino, Michelangelo as well as other painters. Orsi had a curious turn of mind and a knack of assimilating the idiosyncrasies of greater artists, in particular those tending towards an abstract expressionism, often with bizarre results. But his fantasies seem comparatively tame beside the extravaganzas of Giuseppe de Arcimboldi (1527-1593), who amused himself constructing human figures with fruit and vegetables; the result being greatly to the liking of the emperors Ferdinand I, Maximilian II and Rudolph II.

MANNERISM IN ROME

In the period after 1550 Rome became the headquarters of a type of mannerism that might be described as "imitative," as a result of the ever-increasing influx of artists from other parts of Italy and from abroad who came to study Michelangelo and Raphael. Though they oftener drew inspiration from the former, there was also a revival of Raphael's influence at this time. Raphaelesque mannerism was imported into northern Italy by Giulio Romano (1499-1546)—who acted as a sort of dictator of the arts at Mantua from 1524 onwards—and by Perino del Vaga (1500-1547) who decorated the Palazzo Doria at Genoa, where he settled in 1527. Unlike the Florentines and Parmigianino, these two artists had little use for theories, abstraction or studied grace, but practised a forthright realism sometimes needlessly aggressive.

Pellegrino Tibaldi (1527-1596) was born in Lombardy; as painter, sculptor and architect, he had much success at Bologna, at Milan and in Spain. After painting in the manner of Niccolò dell'Abbate, he turned for guidance to Michelangelo, and, by an exceptionally bold handling of forms, achieved an idiom that was largely original, with certain "surrealist" touches like those of the early Florentine mannerists.

Federico Barocci (1526-1612) took a different direction under the joint influence of Raphael and Correggio. Gifted with a delicate feeling for color and an unusual inventiveness in handling form, he might have developed into a front-rank painter but for his over-indulgence in a rather sentimental prettiness.

Towards the close of the century another mannerist painter, Federico Zuccari, who was born in 1542 near Urbino and died at Ancona in 1609, made a great name for himself at Venice and also in Spain and England. A number of influences can be detected in his work, which despite its limitations shows considerable skill. He is better known today as a writer than as a painter.

It might seem that mannerism in Florence was distinguished chiefly by its cult of abstract form, a direct consequence of that lofty intellectual ideal to which 15th-

PARMIGIANINO (1503-1540). THE MADONNA OF THE LONG NECK, 1534-1540. (85 × 52″)
UFFIZI, FLORENCE.

NICCOLÒ DELL'ABBATE (CA. 1509-1571). LANDSCAPE WITH MEN THRESHING WHEAT, CA. 1555-1560.
(33½ × 44″) MUSÉE DE FONTAINEBLEAU.

century Florentine art had owed its greatness. But the most significant result of this movement was the appearance in Northern Italy of a luminist style put to the service of a naturalistic ideal—of which we shall have more to say hereafter. All we need point out at this stage is the gradual decline of creative activity in Central Italy at the time when painters from all over Europe were flocking to Rome. The new impetus given painting in Rome at the turn of the century was due to a Lombard, Caravaggio, and to a Bolognese of Lombard extraction, Annibale Carracci, the former a brilliant innovator and the latter an eclectic follower of the great tradition. As against these men the last champion of mannerist art, the Cavaliere d'Arpino, cut a futile and pretentious figure, quite incapable of demonstrating that mannerism was a force still to be reckoned with.

It was under the auspices of Francis I that the Renaissance came to France; during his reign (1515-1547) intercourse with Italy, which had almost died out in the second half of the 15th century, was actively revived and he summoned many Italian painters to his court. Frenchmen who had accompanied Charles VIII and Louis XII during their peregrinations in Italy had been much impressed by the works of art they saw there and, like Dürer, by the Italian artists' sense of "measure," that is to say order and proportion. Writing in 1529, in his *Champfleury*, Geoffroy Tory declared that the perfection of Italian art was due to their use of dividers and rulers. Between 1504 and 1508 Solario and another painter had come to work for Cardinal d'Amboise at the Château de Gaillon, near Rouen, in Normandy, and in 1513 Emilian painters were called in to decorate Albi Cathedral. But it was left to Francis I to consolidate these links with Italy; he began by summoning Leonardo to France and it was in that country that the great painter ended his life; then in 1518 came Andrea del Sarto, Rosso in 1531 and, a year later, Primaticcio.

Since the French king was constantly traveling from one château to another, the French court had lacked a center where an intellectual life worthy of the Renaissance could develop at leisure. Fontainebleau supplied this need and, with its palaces decorated by Rosso, Primaticcio and Niccolò dell'Abbate, became a very mirror of Renaissance culture. In the court of Fontainebleau conversation bulked as large as hunting among the recreations of the nobility and for the first time women played a part in it. "No courtier can undertake any gallant enterprise of chivalry, unless he be stirred by the conversation and love of woman." Francis I took Castiglione's advice to heart and the presence of women at his court fostered the taste for elegance and witty repartee which was to become a trait of the French character.

What is known as the School of Fontainebleau was launched by the joint efforts of the three painters named above. But they had many French and foreign assistants, some of whose names are known, though it is impossible to distinguish their works from that of the three Italians who set the style of the decorations as a whole. In any case these paintings are in too damaged a condition for us to form any clear idea of the personalities of the various painters; these can be better seen in their drawings and prints. Nevertheless we can discern certain new elements differentiating the Fontainebleau paintings from contemporary Italian works of the same class: notably a special emphasis on elegance and a greater range of decorative effects.

But in his efforts to acclimatize foreign art in France the king did not confine himself to Italian painters; the *bella maniera* might be admirably suited for decorations, but, to his thinking, portraiture called for that minute attention to details, deriving from the miniature, which was peculiar to Flemish art. Jean Clouet (father of François Clouet) was probably of Flemish origin—in any case he never acquired French nationality—and Corneille de Lyon was a Dutchman from The Hague. Yet despite the presence of these foreign elements in the French portrait and the diverse influences contributing to shape the taste of the French king's court, we find a uniformity of style reflecting, we may be sure, the personal predilections of this enlightened monarch.

JEAN CLOUET (CA. 1505-CA. 1541). KING FRANCIS I ON HORSEBACK, CA. 1540. (10½ × 8⅝″)
UFFIZI, FLORENCE.

FRANÇOIS CLOUET (BEFORE 1522-1572). PORTRAIT OF KING CHARLES IX, 1563. (87¼ × 45¼")
KUNSTHISTORISCHES MUSEUM, VIENNA.

To him was due the "modernistic" trend of the art of Fontainebleau, the taste for refined yet sumptuous elegance, the quick-wittedness and liberal outlook on life which were to enter into the pattern of French life at large. The king's sister, Marguerite of Navarre, took part in this cultural movement, not only encouraging writers but doing much to foster that love of nature which found such exquisite expression in the poems of the Pléiade group.

But after the death of Francis I (1547) the Counter-Reformation put an end to these careless raptures; light-heartedness gave place to strait-laced piety.

The most famous portrait painter in France during the first half of the 16th century was Jean Clouet. In 1516 he was appointed court painter at Tours and became the king's *valet de chambre*. In 1529, or soon after, he moved to Paris where he lived until his death, which took place in 1541 or shortly before. Among the portraits that can be more or less certainly ascribed to him are *Claude de Lorraine, Duke of Guise* (ca. 1525, Pitti Palace, Florence) and *Francis I on Horseback* (ca. 1540, Uffizi). Whereas the former has all the characteristics of the 15th-century miniature, a new, essentially decorative style can be seen in the portrait of the king. For between 1525 and 1540 the concepts of Italian mannerism had been gaining ground in France and, though these had no direct influence on Clouet, he felt a need to renovate his art. Unlike his famous contemporary Corneille de Lyon, appointed Painter to the Dauphin, whose court portraits have the gemlike luster of enamel work, he broke with the tradition of the illuminators and developed a personal manner owing little to the past.

On his death his son François took over his official post of king's painter, holding it from 1541 onwards, during the reigns of Henry II, Francis II and Charles IX. He died in Paris in 1572. Three works signed by him are extant: the apothecary *Pierre Quthe* (1562, Louvre), *Charles IX* (Vienna) and *Diane de Poitiers* (National Gallery, Washington). With Diane are her two children and a nurse, and a maidservant can be seen in the background. These works give a good idea of François Clouet's style. The figure of Pierre Quthe is located in its spatial context with a dignity akin to that of Italian portraits, but the meticulous execution is typically Flemish, and Clouet has succeeded in combining the two styles on remarkably ingenious lines. In *Diane de Poitiers* we find a mannerism more in the Flemish than the Italian style, and there is a marked contrast between the studied formalism of the nude and the realistic, free-and-easy rendering of the nurse. A similar anomaly can be seen in some of his court portraits. The disposition of the figures in *Charles IX* (Vienna) and *Henry II* (Louvre and Pitti Palace, Florence) recalls that of Titian's *Charles V* and *Philip II*, but here too the attention given to details, the exquisite nicety of handling and studied elegance strike a new, original note. Mention may also be made of Clouet's *Elizabeth of Austria* (1571, Louvre) in which the sumptuously clad figure is treated in a style much more Flemish than Italian, as is evident if we compare it with, for example, Bronzino's *Eleonora de Toledo*.

The unidentified artist known as the Master of Flora, to whom are attributed, amongst other works, the *Triumph of Flora* (Feilchenfeldt Collection, Zurich) and the

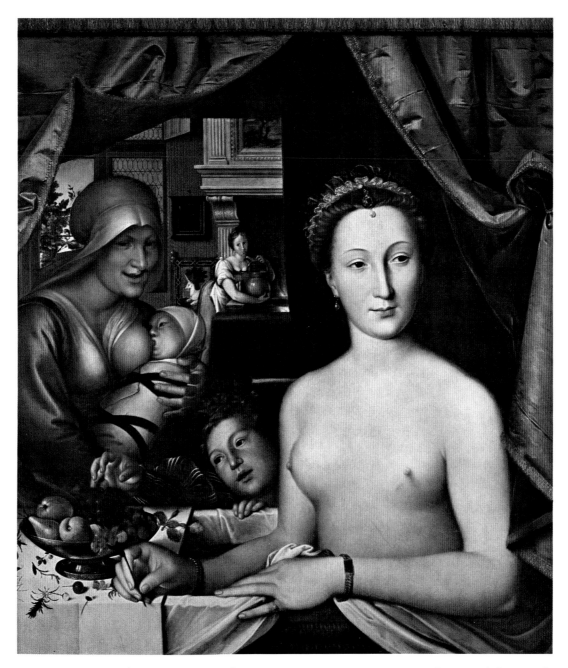

FRANÇOIS CLOUET (BEFORE 1522-1572). DIANE DE POITIERS, BETWEEN 1560-1570. (36¼ × 32″)
NATIONAL GALLERY OF ART, WASHINGTON (SAMUEL H. KRESS COLLECTION, LOAN).

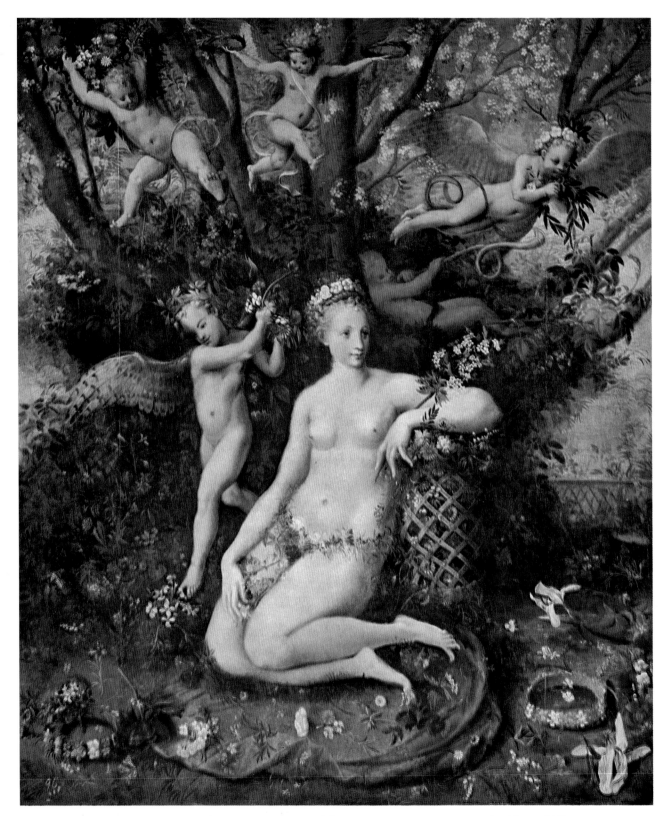

MASTER OF FLORA (ACTIVE CA. 1540-1560). THE TRIUMPH OF FLORA. (51½×43¼″)
PRIVATE COLLECTION, VICENZA (FORMERLY FEILCHENFELDT COLLECTION, ZURICH).

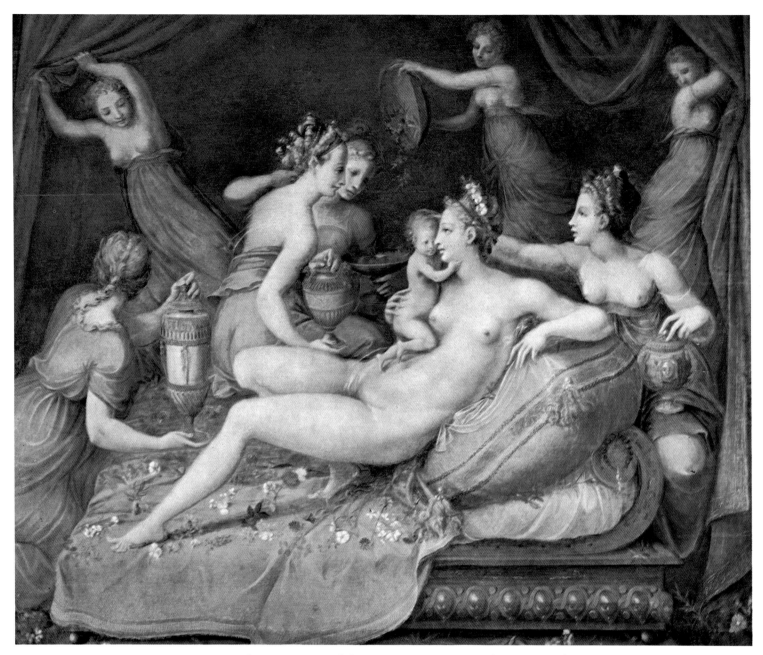

MASTER OF FLORA (OP. CA. 1540-1560). THE BIRTH OF CUPID. (42½ × 51⅜″)
BY COURTESY OF THE METROPOLITAN MUSEUM OF ART, NEW YORK.

Birth of Cupid (Metropolitan, New York), was evidently a highly cultured man, gifted with a nimble wit and not a little originality—despite the fact that his technique recalls Primaticcio's, some of his motifs are taken from Bronzino and the colors owe something to Correggio. For this artist's exquisite refinement, his defiance of the rules of composition and his knack of getting charming effects by happily inspired inaccuracies of drawing and proportion are both a reflection of the French spirit in those golden years and a synthesis of the aspirations of the School of Fontainebleau.

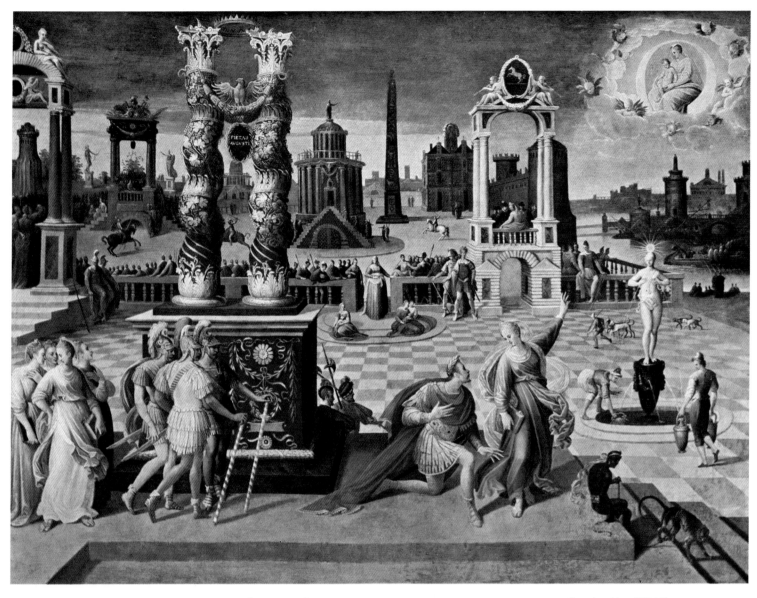

ANTOINE CARON (1521-1599). AUGUSTUS AND THE SIBYL OF TIBUR, CA. 1580. (49¼×66¾″)
LOUVRE, PARIS.

About Antoine Caron, unlike this nameless master, much is known. He was born
at Beauvais in 1521 and died in Paris in 1599. After working for Francis I until 1540
and collaborating with Primaticcio and Niccolò dell'Abbate on the Fontainebleau
decorations, he was appointed court painter to Catherine de' Medici. The decorations
he made to celebrate the return of Henry III from Poland in 1573 and for the festivities
in connection with the wedding of the Duc de Joyeuse in 1581 were universally admired.
Jean Dorat and Louis d'Orléans wrote verses in his honor. A complete list of his works
is now available, largely owing to recent research-work by J. Ehrmann.

A signed painting by Caron in the Louvre depicts the *Massacres under the Trium-
virate*, in which we may perhaps see an allusion to the bloodshed attending the Wars

of Religion then in progress. His best picture is probably *Astronomers studying an Eclipse* (Anthony Blunt Collection, London), which unmistakably alludes to the Huguenots; for in 1571 an eclipse actually took place accompanied by a rain of fire, which was interpreted as a token of divine displeasure. *Augustus and the Sibyl of Tibur* is a pictorial transcription of one of the Incarnation and Nativity mystery plays performed in the Tuileries in the presence of Catherine de' Medici. The abstract symbolism of these pictures, reconstructions of the life of ancient Rome—one sometimes has an impression that the artist wishes to parade his erudition—gives them a certain frigidity. Though Caron was the most famous French painter of his age, he is not the best; he owed his success most likely to the fact of being a *persona grata* at court. A change of heart and a new type of artist were needed if French painting was to regain its former eminence.

BARTHOLOMEUS SPRANGER (1546-1611). VENUS AND ADONIS, CA. 1592. (53 × 43″)
RIJKSMUSEUM, AMSTERDAM.

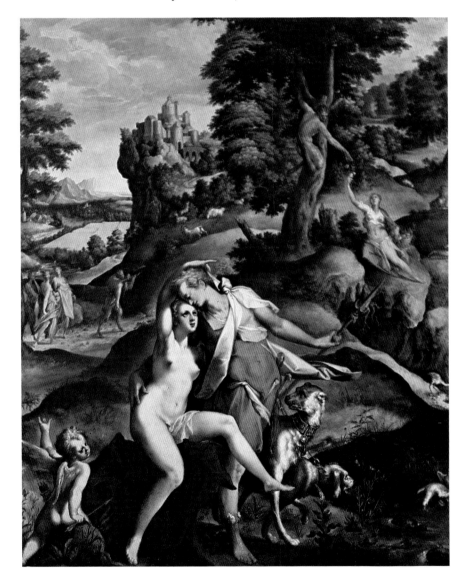

ANTONIO MORO (CA. 1519-1576). SELF-PORTRAIT, 1558. (44½ × 34¼")
UFFIZI, FLORENCE.

We have already seen that Brueghel's journey to Rome had no effect on his style; his attitude to art remained throughout his life far closer to that of Bosch than to the classical ideal deriving from Greek sculpture. Jan van Scorel, on the other hand, was profoundly influenced by what he saw in Rome and, turning his back on the art tradition of his homeland, took over the Italian manner and even sought to prettify it. Dominicus Lampsonius, author of *Pictorum aliquot celebrium Germaniae inferioris effigies*, published in 1572 at Antwerp, inscribed Scorel's portrait with the legend: "To me shall be accorded evermore the merit of having made known to the Belgians that none may aspire to the name of painter unless he has seen Rome and learnt there to ply a thousand brushes and lavish color, so as to create works worthy of renown." Similarly in his *Descrittione di tutti i Paesi Bassi* (1567), Ludovico Guicciardini explained that when painters and sculptors of the Low Countries went to Rome they did so with an avowed intention of discarding traditional Flemish style and learning that of the Italians. Carel van Mander (1548-1606) declared that by taking the Ancients as

exemplars, Rome and Florence had "recaptured nature as she truly is," whereas the Flemings had kept to "vulgar" nature.

Among Scorel's pupils was Antonio Moro, who was born about 1519 at Utrecht and died in 1576 at Antwerp. After visiting Rome in 1550 and 1551, and Portugal in the following year, he became the portrait painter most in demand at the courts of Brussels, Lisbon, Madrid and London. The *Portrait of Mary Tudor, Queen of England* (Prado) is typical of his "official" style. His presentation of the figures as a real mass existing in space shows a capacity much like Titian's for producing an effect of actuality. But he cannot bring himself to omit any detail, with the result that in his portraits the new Titianesque vision, blurred by a plethora of accessories, loses much of its vitality. All the same he had quite amazing technical ability and portrayed his models with an objective precision rarely equaled. Moro's sitters were on several occasions the same as Titian's and he must have realized the peril of competing with the Master on his own ground. Nevertheless all but an understanding few were loud in admiration of these portraits, more detailed and materialistic than those of the great Venetian. But there is no denying their convincingness, and it is on his portraits that Moro's reputation rests, for his imaginative works are relatively feeble.

Pupil and rival of Jan van Scorel, Martin Heemskerck (1498-1574) spent most of his life at Haarlem. During a stay in Rome, some time between 1532 and 1535, he painstakingly sketched the Roman monuments and developed a passionate admiration for Michelangelo. But, having come to Rome relatively late in life, he kept his natural vision unimpaired, as can be seen in

PIETER AERTSEN (1508-1575). THE COOK, 1559. (63¼ × 31″)
MUSÉE DES BEAUX-ARTS, BRUSSELS.

LUCA CAMBIASO (1527-1585). THE VIRGIN WITH A CANDLE, CA. 1570. (57 × 43″)
PALAZZO BIANCO, GENOA.

his admirably forceful portraits and the *St Luke painting the Virgin* (Haarlem), treated in the manner of a genre piece. St Luke in his outlandish costume, the angel holding a torch to light the scene, the winsome group of the Virgin and Child—all are elements answering to the ideal of the Netherlands, certainly not to that of Roman art. In the *Lamentation over the Dead Christ* (Delft), however, Roman influences are all too obvious; here the artist has reined in his imagination, though falling short of classical serenity.

Bartholomeus Spranger (1546-1611), who hailed from Antwerp, had much success in Rome and Prague. After visiting Paris in 1565, he went to Italy where he came under the influence of Primaticcio, Parmigianino and the Zuccari. In 1570 he was appointed official painter to Pope Pius V, in 1575 to the Emperor Maximilian II (at Vienna) and after that to the Emperor Rudolph II (at Prague). Propagated by engravings of his paintings made by Sadeler and Goltzius, his style won many imitators in the Netherlands, Italy and France. His art is the last manifestation of the mannerism of fantasy; the *Venus and Adonis* (Rijksmuseum, Amsterdam) is a typical example, notable being the sinuosity imparted not only to bodies but also to trees and mountains. With its artificial liveliness and surface elegance, this picture is a wholly intellectual creation, there is more artistry than art.

Pieter Aertsen (1508-1575) of Amsterdam, though his career followed much the same course as Heemskerck's, was more accessible to the new ideas then gaining ground in all parts of Europe. There is no proof that he ever went to Rome; he worked in Antwerp from 1535 to 1556, and after that in Amsterdam. Even in his religious pictures we can see a conflict between mannerist and realist tendencies, which, notably in the case of the *Adoration of the Magi* (Deutzen Hofje, Amsterdam), led to unsatisfactory results; to some of his other works, however, this apparent conflict lends an added interest. Aertsen specialized chiefly in pictures of fruit and, for this reason, has been regarded as one of the first exponents of the still life. He loved to "make the portrait" of everything he saw, and it was through the eyes of a portraitist that he painted fruit and vegetables or anonymous figures in genre-scene settings, such as *The Cook* (Brussels). In this famous picture he centered his attention on the color-light complex building up the woman's form; thus *The Cook* is out of line with Roman mannerist tradition, and may, rather, be assimilated to the Venetian trends sponsored, for example, by Tintoretto and Bassano.

It is thought that Aertsen migrated to Amsterdam so as to escape falling foul of Frans Floris, a thorough-paced mannerist, who was making a great name for himself in Antwerp, his birthplace, then the chief art center of the Netherlands. Floris was in Rome between 1541 and 1547 and his painting reflects an academic Romanism modeled on Michelangelo and Vasari.

The need felt by the Flemings to adjust mannerism to realism answered to an innate tradition of the race, and in the result the new realism came to be associated with luminist procedures. Already in the second half of the century mannerist painters were concentrating their attention on effects of light and shade suggested by those of Titian, Tintoretto and the Venetians in general. This can be seen in the work of

various members of the Campi family of Cremona—Antonio Campi (1525?-1587) in particular—and even more noticeably in that of Luca Cambiaso (1527-1585), a Genoese painter who, following in the path of Beccafumi, used light to bring out the dramatic or intimate content of his subjects. Outstanding examples are his delightful *Virgin with a Candle* and *Christ before Pilate* (both in Genoa, Palazzo Bianco). Throughout the 17th century "luminism" was to advance from strength to strength in the wake of Caravaggio, its most spectacular exponent in Rome.

EL GRECO In discussing the art of Titian, Tintoretto and Veronese we pointed out that these three painters, while assimilating the mannerist elements that had found their way to Venice, transformed them almost out of recognition and created a style of painting that was brilliantly original. Something the same is true of El Greco, but with a difference; he did not, like the Venetians, integrate the machinery of mannerism into his personal style, but juxtaposed it, stressing to the utmost their antinomy. Thus more and more as his genius ripened, and particularly during the last twenty-five years of his life, he played off mannerist line against constructive color, and with the resultant discords achieved an expressive power unsurpassed in the whole history of art. This is why, after excluding Tintoretto's art from the category of mannerism, we would include El Greco among the mannerists, though needless to say we are well aware that he left mannerism far behind and in fact contributed decisively to the formation and triumph of Baroque.

At the time when mannerism seemed to be lapsing into Roman academicism or Nordic quaintness El Greco harked back to its anti-classical, irrational elements—those that had characterized it at its birth. And it is hardly necessary at this time of day to emphasize the boldness and the genius with which he incorporated them into his art, an art singularly congenial to our modern taste.

Few painters are so closely studied and so universally appreciated at the present time; but El Greco's contemporaries, too, were fully alive to his genius. Then came an eclipse; until the advent of Romanticism he was dismissed out of hand as belonging to the "lunatic fringe" of art. It was perhaps the collection of his works made in Paris by King Louis Philippe that heralded his return to favor, and since then his reputation has risen steadily.

Domenikos Theotokopulos, known as "the Greek," was born in Crete in 1541 and died in 1614 at Toledo, in Spain. From 1565, perhaps earlier, he worked in Venice, as Titian's pupil; in 1569 he went to Rome, stopping on the way at Parma. While in the capital he was the guest of Cardinal Alessandro Farnese and his librarian Fulvio Orsini. After a longish stay in Rome, he migrated to Spain; the first mention of his presence in that country is dated 1577. He was then commissioned to paint a series of altarpieces for the convent of Santo Domingo el Antiguo in Toledo and he also made a picture, the *Espolio*, for the local cathedral. The only work he did for King Philip II was the *Martyrdom of St Maurice*, intended to be hung in the Escorial. In 1586 he started work on the *Burial of Count Orgaz* for the church of Santo Tomé at Toledo;

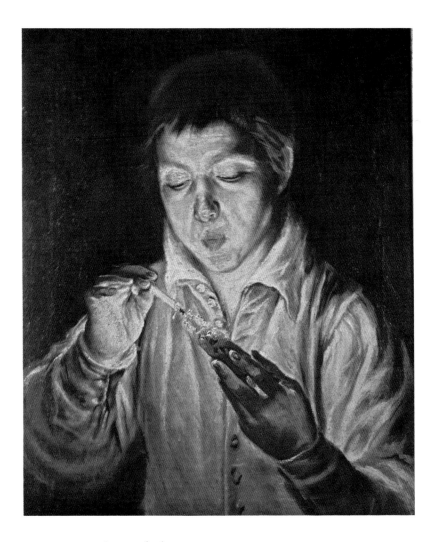

EL GRECO (1541-1614). BOY KINDLING A FLAME, CA. 1570-1575.
(23⅝ × 19⅝″) MUSEO NAZIONALE, NAPLES.

thereafter he was given many orders for paintings and sculpture by local ecclesiastical authorities and by churches in the neighborhood. A few days after El Greco's death his son Jorge Manuel made an inventory of the works left by his father; one hundred and twenty-six pictures figure in it.

Byzantine influence is strongly marked in the *Adoration of the Magi* (Benakis Museum, Athens), *Mount Sinai* (Baron Hatvany Collection, Budapest) and the *Modena Polyptych*. We have so far no means of deciding whether it was in Crete that El Greco acquired his "Byzantinism," or in Venice, where a whole group of Greek painters, known as "Madonneri," were turning out countless representations of the Virgin seen through Greek eyes. They may not have been great artists, but at least they transmitted the forms of Byzantine painting, as consecrated by its glorious past. Anyhow from the critic's point of view it is less important to determine whether the many paintings ascribed to El Greco are in all cases by his hand than to discern what Byzantine elements (other than innate traits due to his Greek origin) were "constants" in his art.

For many centuries Byzantine painting had no longer been based on visual experience; the Byzantine artist started out from an abstraction, an ideal concept, and went on to clothe it in material, individual form. His creative process was exactly the opposite of that of the classical artist, who made the concrete the point of departure in his pursuit of the ideal. For the Byzantines, the abstract model, being charged with mystical associations, was an indispensable basis to the concrete work of art. Obviously the mannerist approach to art had much in common with that of the Byzantines, the main difference being that whereas the latter started out from a predetermined archetype, the mannerist painter's ideal concept was a strictly personal creation, not imposed on him by others. Thanks to his Byzantine training El Greco could readily accept many of the procedures of mannerism.

As for his iconography, we must remember that Byzantine art was essentially ritual in nature. The Byzantine artist did not treat the episodes of sacred history as so many aspects of the human predicament but as a series of rites charged with symbolic meanings and emanating from an otherworldly source. This is why in Greco's art action is ruled out and stress laid on the psychological content of the scene. His color too—and this is one of the most striking features of his painting—stems from this tradition. In Byzantine art color values are created by the relations of hues between themselves, not by light-and-shade effects. And in El Greco's painting the colors play a leading part, clashing or harmonizing with each other, and stepped up to such intensity as to replace light.

These three concepts which El Greco took over from the Byzantine tradition— forms derived from abstract prototypes, composition within a ritual frame of reference, and color harmonies owing nothing to the play of light—were diametrically opposed to all the principles of Cinquecento Venetian art. But he had an amazing gift of assimilation and when he worked in Titian's studio quickly learned the secrets of tonal painting (the subtle variations imparted to each color by the action of light), dramatic composition (the relation between lay-out and theme) and, finally, the handling of

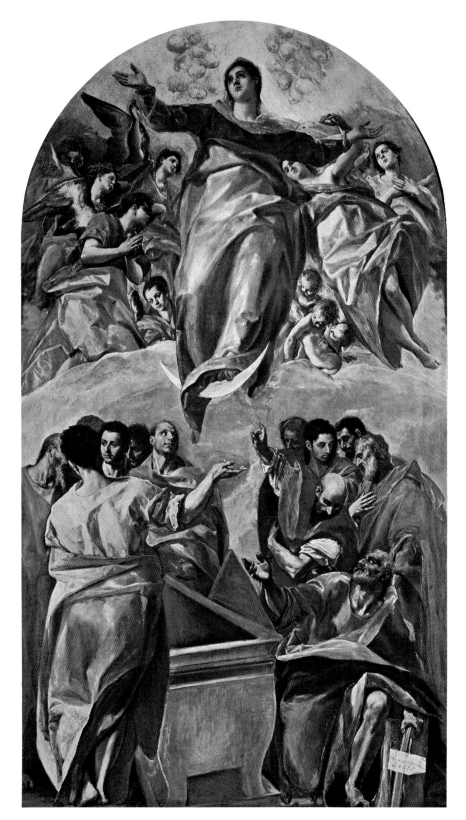

EL GRECO (1541-1614). THE ASSUMPTION OF THE VIRGIN, 1577. (13 FT. 2 IN. ×7 FT. 6 IN.)
THE ART INSTITUTE OF CHICAGO IN MEMORY OF ALBERT ARNOLD SPRAGUE.

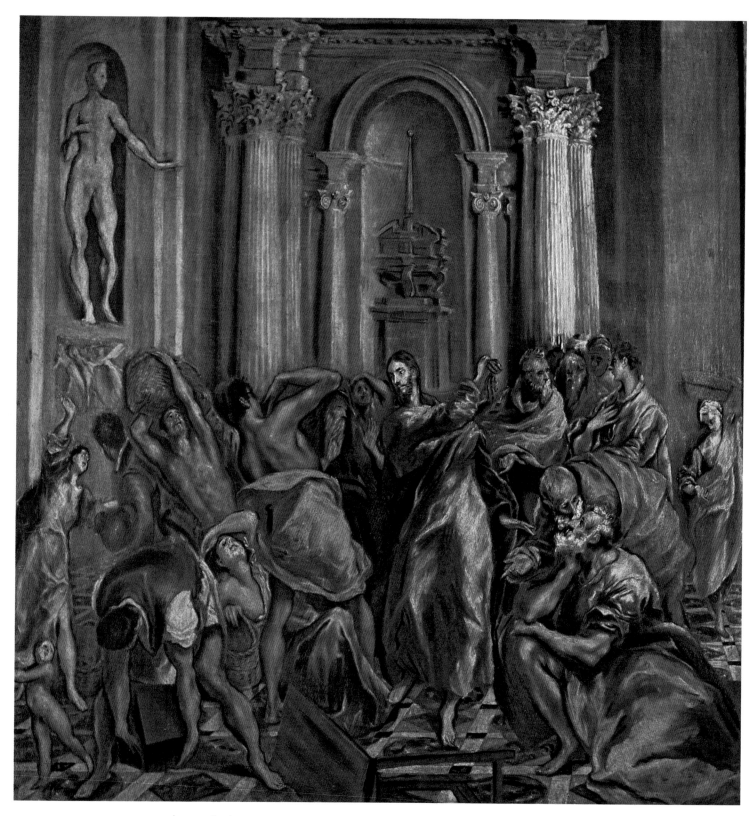

EL GRECO (1541-1614). CHRIST DRIVING THE MONEY CHANGERS FROM THE TEMPLE, 1605-1614.
(41¾ × 41″) CHURCH OF SAN GINÉS, MADRID.

volumes and the movement of bodies (that is to say the art of disposing bodies in space): in short, the basic elements of Titian's style. He also learnt the virtues of the "touch" or aptly placed dash of color, of a judicious unfinish, and all the possibilities afforded by the new vision of reality.

But this assimilation was on a purely painterly level and did not involve any adhesion to Titian's attitude to life, which, ruling out all mysticism, led to a glorification of the material aspects of existence. Among the many conflicting tendencies El Greco had to reconcile, this antinomy between his innate mysticism, due to his Cretan upbringing, and the faith in nature revealed to him in Venice, was one of the most arduous problems he had to face in his formative years.

When working under the auspices of Titian, El Greco observed with interest what other painters, younger than the Venetian master but older than himself, were doing. Instinctively he was drawn to Tintoretto, with whose mystical outlook he had so much in common and who like himself put all his ardor into the depiction of sacred subjects. Greco had no trouble in taking over Tintoretto's light effects, more accentuated yet simpler than those of Titian. We also find affinities with Bassano; aside from certain similarities of composition (whose common source may be traced to engravings available to both artists), these affinities can be accounted for by the fact that Bassano's renderings of visual reality were less elaborate than Titian's.

However, stress must be laid on the mannerist factor, which played a vital part in the shaping of El Greco's art. While in Venice, he had opportunities of familiarizing himself with the mannerist procedures which had found their way there, as indeed to all art centers of the day; thus the elongation of figures, derived from Parmigianino, had become a common practice with Venetian painters. And the tendencies acquired in Venice were reinforced during his Roman sojourn; with the result that El Greco's mannerism is more pronounced than that of any other painter. We are inclined to agree with José Camón Aznar when he says that Michelangelo and Roman mannerism directly influenced him both in his preference for a certain type of figure and in his habit of constructing his composition in height, as also in his way of rendering garments. Thus it would seem that his contacts with Roman mannerism helped El Greco to free himself from the "tonalism" of the Venetians.

But apart from the influences operating in Venice and Rome, El Greco's mannerism may well be due to an instinctive sympathy with the anti-classical reaction. For as against Titian's materialistic vision of reality, mannerism stood for spiritual aspiration, a nostalgic yearning to return to the Middle Ages, to transcendence, to the abstract— in a word, to Byzantine tradition. Between the Byzantines who started out from the abstract and thence proceeded to the concrete and the mannerists who reversed the process, there is a connecting link: El Greco's art. As was only to be expected, he failed to attain his style at a moment's notice; long years were needed for its ripening and the discovery of ways and means of resolving his inner conflicts. Needless to say, an artist of genius can create masterpieces even though his style is still in the course of formation; nevertheless it was not until El Greco settled at Toledo that he found

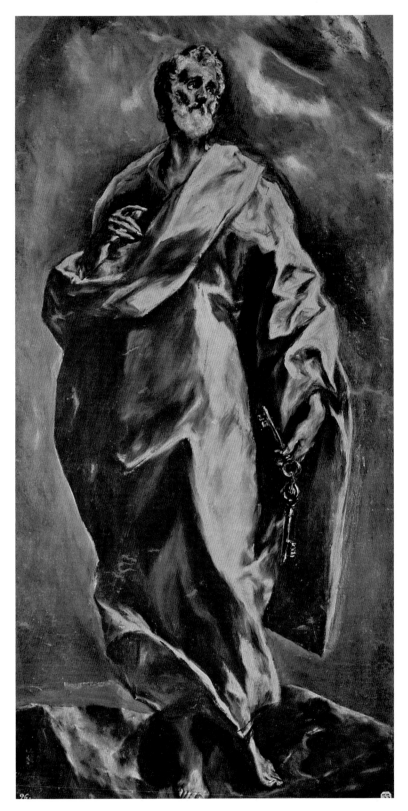

EL GRECO (1541-1614). ST PETER, CA. 1606-1608. (81½ × 41½″)
CONVENT OF THE ESCORIAL.

himself, completely and triumphantly. This is evident when we compare the successive versions of *Christ driving the Money Changers from the Temple*. In the early ones, painted in Italy, forms are fully modeled, whereas in the later versions—that in the National Gallery, London (1600), and that in the Church of San Ginés, Madrid (the one we reproduce)—they are sublimated into wraiths of light, and the rendering of space is reduced to symbolic indications of its existence. And whereas in the early works we are still conscious of an uneasy interplay of different traditions, in the last their fusion is complete, the style harmoniously integrated.

EL GRECO (1541-1614). THE LAOCOÖN, CA. 1610-1614. (54⅛ × 67⅞″)
NATIONAL GALLERY OF ART, WASHINGTON (SAMUEL H. KRESS COLLECTION).

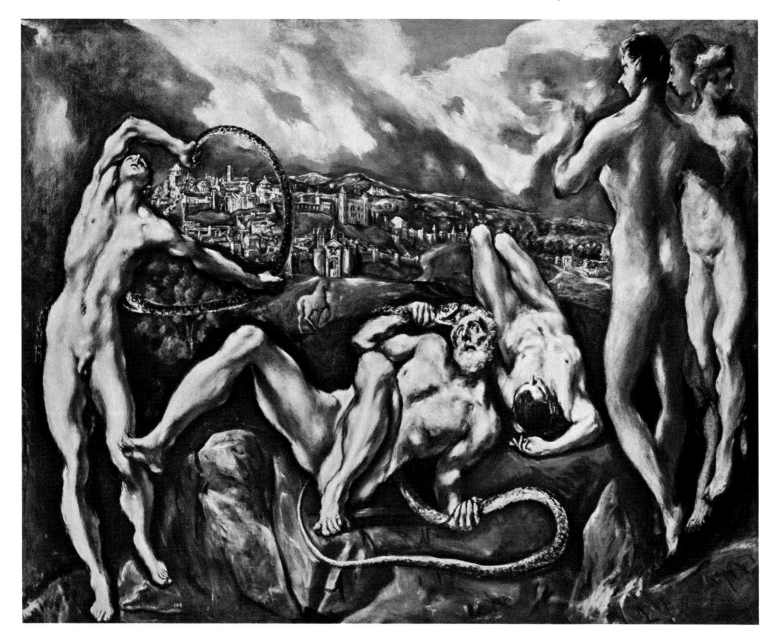

When El Greco arrived at Toledo, the ancient capital had lost nothing of its prosperity despite the fact that Philip II had transferred his court to Madrid in 1561. There was a flourishing trade in silk and weapons—the famous "Toledo blades"— the Cathedral was one of the wealthiest in Spain and many of the most enlightened spirits of the age lived there, among them Cervantes, Lope de Vega, Góngora and St John of the Cross. The atmosphere of devout piety and mysticism then prevailing in Toledo was just what was needed to bring El Greco's genius to flower. In 1577, perhaps the year of his arrival in Spain, he painted the *Assumption of the Virgin*, central panel of one of the altarpieces in Santo Domingo el Antiguo (now in the Art Institute of Chicago). Sixty years had passed since Titian had painted his great *Assumption* in the Frari church, one of the earliest works in which he gave expression to his new vision of reality. But Greco, in Toledo, cast off his master's influence. He did away with space, brought forward the scene into the foreground and "presented" images instead of representing an event. True, a gust of emotion sweeps through those figures, we can sense their restlessness; but it is not co-ordinated in movement, still less in any action. Nevertheless this picture has tremendous expressive power and, though volumes of bodies are not suppressed, their physical aspects are wholly subordinated to the spiritual content.

El Greco was a superb portrait-painter, with a gift for probing into his model's soul and imprinting on the face what he discovered there. Looking at his *Cardinal Don Fernando Niño de Guevara* (Metropolitan, New York), we feel that here we have the typical Grand Inquisitor, shrewd, proud and wary, capable of being ruthless on occasion. No less unforgettable are the portraits of his Toledan friends, amongst others *Fray Hortensio Felix de Paravicino* (Boston), *Don Jerónimo de Ceballos* (Prado) and *Don Antonio de Covarrubias* (Louvre and Museo del Greco, Toledo). There was a phase in his evolution as an artist when El Greco struck a perfect balance between the grandiose vision of his large-scale compositions and the psychological insight of his portraits; I have in mind the time when he painted his most famous work, the *Burial of Count Orgaz* (Santo Tomé, Toledo). The burial scene itself centers on the blaze of gold and silvery light streaming from the vestments of the priests and the dead Count's armor, standing out against a dark background formed by the black-clad mourners. The upper half of the picture shows God surrounded by a splendor of light and fantastically shaped clouds. The composition may recall Byzantine art, but it is executed with an objective vigor worthy of Titian. Each detail, celestial or terrestrial, plays an exact and vital part in the composition and contributes to the flawless unity of the whole. This period of perfect equilibrium falls between the years 1585 and 1590.

During his final period, beginning about 1590, El Greco tended to give still freer play to his imagination and to lay yet more stress on emotive elements. The extreme elongation of bodies, devoid of any action, in which he now indulged, was perhaps a reminiscence of Italian mannerism and the climate of his 'prentice years, as was a special, flame-like lighting that seems an emanation of the soul within. To this period belongs the series of "imaginary portraits" of apostles and saints: St Francis, St John

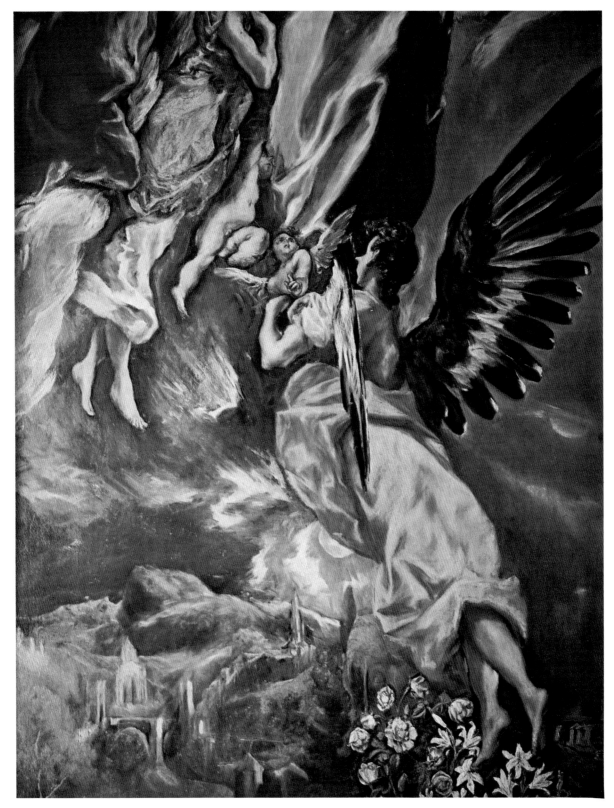

EL GRECO (1541-1614). THE ASSUMPTION OF THE VIRGIN (DETAIL), CA. 1608-1613.
MUSEO DE SAN VICENTE, TOLEDO.

the Baptist amongst others. The *St Peter* in the Escorial is not only a magnificent piece of painting but also a striking demonstration of El Greco's gift for revealing the subject's inner life by means of wholly unrealistic forms.

Very few secular pictures figure in his œuvre. One of these is of exceptional interest: the *Laocoön* (National Gallery, Washington), dated to the last years of his life and mentioned in the inventory compiled after his death. The singular thing about the *Laocoön* is that it is obviously a caricature—of the famous Greek statuary group discovered in 1506 in Rome. Other caricatures had been made of it, for example one by the engraver Boldrini who depicted the ill-starred family as monkeys. El Greco contented himself with distorting the figures, placing on one side of the scene indifferent spectators and in the background, framed by a sort of human architecture, a view of Toledo (doing duty for one of Troy). The anti-classical bias manifest in this curious scene is characteristic of his last works, as it was of his earliest.

It was in religious scenes that El Greco had the subjects best adapted to the luminist style, the patterning in streaks of light, of his final period. Under his brush the *Immaculate Conception*, the *Nativity*, the *Baptism of Christ*, *Christ in the Garden of Olives*, the *Crucifixion* and the *Resurrection* were sublimated into mystical visions ranking beside those of Santa Teresa.

None of the treatises on art which El Greco is known to have written has come down to us. All we have is an inscription on the *View and Plan of Toledo* (Museo del Greco, Toledo) painted in 1609 or thereabouts. In it he explains that "so as to give the greatest possible size to the figures in the scene of the Blessed Virgin handing a chalice to St Ildefonso, I thought fit to show them as heavenly bodies, high in air, like lights which, though small and distant, seem larger than reality." This might equally apply, as Lopez Rey has pointed out, to the other *View of Toledo* (Metropolitan, New York), some of whose elements seem like leaping flames.

There in fact we have the key to El Greco's art. Whether his figures be terrestrial or celestial, they soar, patterned in light, illumined by the love divine, aspiring spirits freed from those bodies which the Renaissance had "discovered" and transmuted in a synthesis of mind and matter. This vision of a world of disincarnate, flame-like spirits was perhaps the necessary culmination of a genius like El Greco's; the remarkable vitality of Velazquez' color may have owed something to it, but it could not serve as a point of departure for the art of the future. On the contrary, if modern art was to come into being, it was incumbent on the artist to come down to earth again and return to the study of the living body, trying to elicit from it the secret of a human personality, without surrendering to the enchantments of a visionary world.

INDEX OF NAMES

LIST OF ILLUSTRATIONS

INDEX OF NAMES

LIST OF ILLUSTRATIONS

PRINTED BY
IMPRIMERIES RÉUNIES SA
LAUSANNE

BINDING BY
GROSSBUCHBINDEREI H.+J. SCHUMACHER AG
SCHMITTEN (FRIBOURG)

Photographs by Louis Laniepce, Paris (pages 20, 26, 51, 55, 60, 99, 101), Claudio Emmer, Venice (pages 27, 35, 46, 54, 56, 68, 69, 80, 81, 83, 85, 86, 89, 90, 91, 94, 102, 105, 113, 124, 126, 129), Hans Hinz, Basel (pages 7, 8, 12, 13, 14, 15, 17, 22, 23, 37, 40, 58, 59, 63, 64, 65, 67, 77, 79, 95, 132, 134, 137), Arte e Colore, Milan (pages 45, 47, 96, 97), Henry B. Beville, Alexandria, Va. (pages 31, 119, 121, 131, 135), Karl Meyer, Vienna (pages 3, 39, 117) and Walter Steinkopf, Berlin (page 70).

PRINTED IN SWITZERLAND